ALDERSHOT

THROUGH TIME

Paul H. Vickers

AMBERLEY PUBLISHING

First published 2012

Amberley Publishing
The Hill, Stroud
Gloucestershire, GL5 4EP

www.amberley-books.com

Copyright © Paul H. Vickers, 2012

The right of Paul H. Vickers to be identified as the
Author of this work has been asserted in accordance
with the Copyrights, Designs and Patents Act 1988.

ISBN 978 1 4456 1026 9

British Library Cataloguing in Publication Data.
A catalogue record for this book is available from
the British Library.

Typeset in 9.5pt on 12pt Celeste.
Typesetting by Amberley Publishing.
Printed in the UK.

Introduction

Aldershot is a town with a rich and unique heritage. Before 1853 it was a small rural village with a population recorded by the 1851 Census of only 875. The village centred around the parish church, the Manor, and two inns, the Red Lion and the Beehive. In the village were a baker, butcher, grocer, blacksmith, wheelwright, carpenters, and a veterinary surgeon. For the rest of population the main occupations were farmers or agricultural labourers, plus some cottage industries such as potters and brickmakers.

Life for the people of Aldershot changed completely after 1853 when Lord Hardinge, Commander-in-Chief of the Army, recommended that the land of Aldershot Heath should be purchased to establish the first permanent training camp for the Army. The location was well sited for communications to London and to the naval base at Portsmouth, there was an ample water supply and, as it was land unsuited to agriculture, large areas could be bought cheaply. The government began buying the land in January 1854, the following month contractors started building wooden huts for the camp, and the first soldiers took up residence on 7 May 1854 when five officers and 103 other ranks of the 94th Regiment of Foot marched to Aldershot from Windsor. Subsequently soldiers poured into Aldershot Camp, especially after the Crimean War, and by 1859 there were 15,263 military personnel stationed here.

Along the edges of the garrison numerous entrepreneurs set up business in hastily erected wooden buildings to take advantage of the opportunities presented by the largest permanent Army camp in the country. As the Camp took on a more permanent character this new town, about a mile west of the old village, also replaced the wooden shanties with proper streets and brick buildings. The fortunes of the town and the Army grew together. In only a few decades the Victorian town was vibrant and prosperous, the Army replaced its wooden huts with fine brick barracks, and the town boasted shops, churches,

schools, hospitals, public houses, theatres, and businesses of all kinds to cater for the military and civilian population alike.

After the Second World War the Army reduced in size and became less reliant on the neighbouring town, and as a result patterns of trade, business and employment in the civilian town also changed. Today the Army is still an important presence, with around 4,800 personnel in the garrison, but the town has diversified to find new sources of prosperity and attract new residents. Major changes are coming over the next few years. The military town is being redeveloped to bring the soldiers' accommodation up to a standard appropriate for the Army in the twenty-first century. The Army is concentrating onto its land north of Alison's Road, freeing 148 hectares of land from the old South Camp for civilian development under the Aldershot Urban Extension project. In the town the new Westgate centre is due to open in late 2012, which the authorities believe will rejuvenate the town centre by providing new shopping, restaurant and entertainment outlets. Despite these changes the Victorian town is still much in evidence, and it is this which gives Aldershot its special character. Aldershot remains proud of its military heritage and still proclaims itself the 'Home of the British Army'.

This book aims to show what has changed about this fascinating town, and what remains of the past. It begins with the area of the original Aldershot village, before illustrating the arrival of the Army, the growth of the Camp and the changes to the garrison over the years. The focus then moves to the town centre, to show how this developed over a relatively short time and which parts of the Victorian legacy endure. From the town centre it moves to look at the expanding town, some typical residential areas, a selection of local business, sports, leisure and recreation, and finally a few of the area's many monuments and memorials.

In a short book it is impossible to include every aspect of such an abundant history. However, this selection of historic and modern photographs provides an insight into the story of Aldershot and shows how it has changed and developed through time.

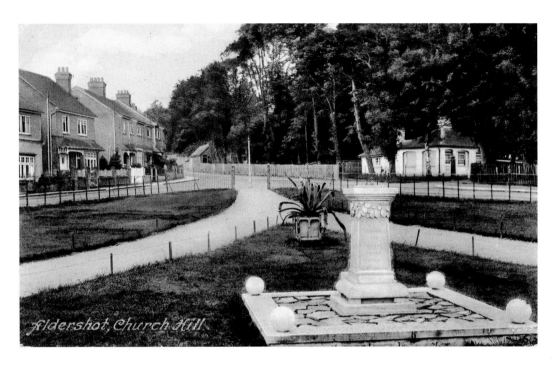

Aldershot Village Green

Before 1853 Aldershot was a small village with most of its buildings within a triangle formed by the parish church, the Red Lion inn, and the Beehive public house. The small patch of grass and flowers at the bottom of Church Hill marks the site of the village green. The photograph above dates from around 1924 and is looking up Church Hill, with the Manor Park lodge on the right. The modern photograph shows the view looking east towards Ash Road.

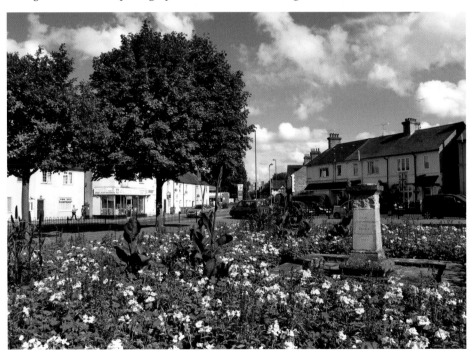

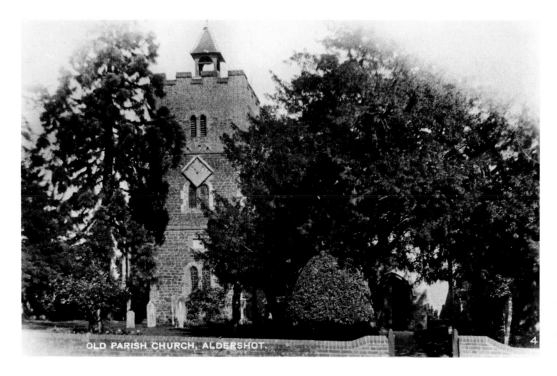

OLD PARISH CHURCH, ALDERSHOT.

The Ancient Parish Church of St Michael the Archangel

The parish church dates from the twelfth century, with the oldest part of the church now forming the Lady Chapel. The brick tower was built around 1600 with the clock and turret bell installed in 1799. After the arrival of the Army the church was extended in 1865 and again in 1911 to cope with the growing congregation. Since then it has little changed, as seen by comparing the photograph from the 1920s with the present-day view.

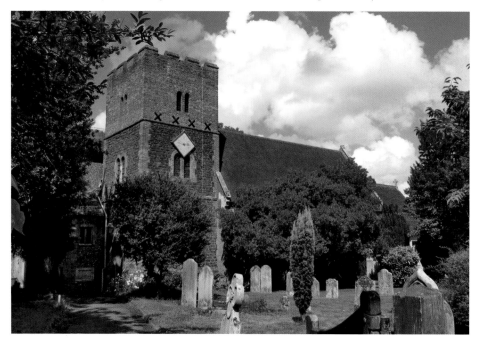

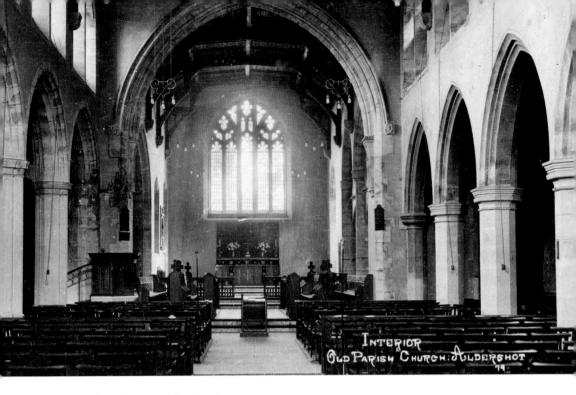

The Interior of the Parish Church
The older photograph dates from around 1920 and shows the nave and chancel built in the 1911 extension of the church. The main changes visible in the modern photograph are the rood screen, erected in 1931 in memory of church benefactor Naomi Robertson, and the pulpit canopy erected in 1926.

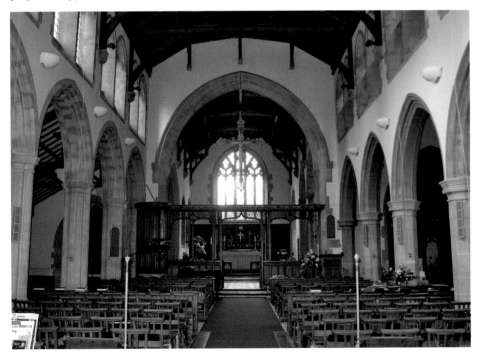

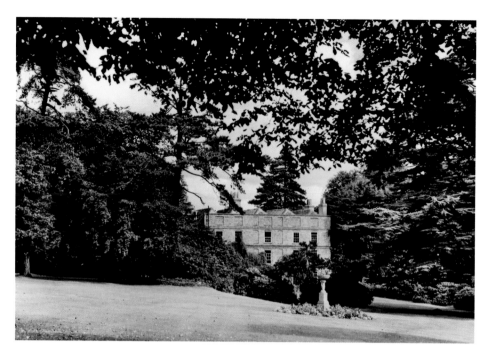

Aldershot Manor

Seen through the trees in the photograph dating from around 1930 is the Manor House built in 1670 by the Tichbourne family to replace an older building in Aldershot Park. Although it has undergone numerous external and internal alterations over the years, the building is still in fine condition and today is used as offices.

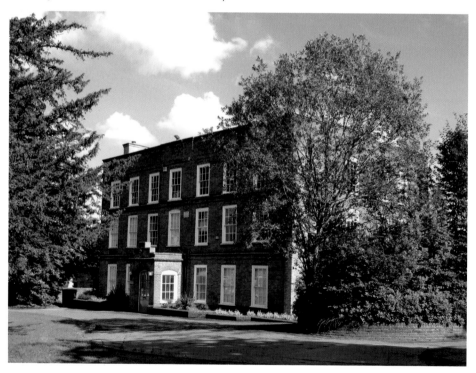

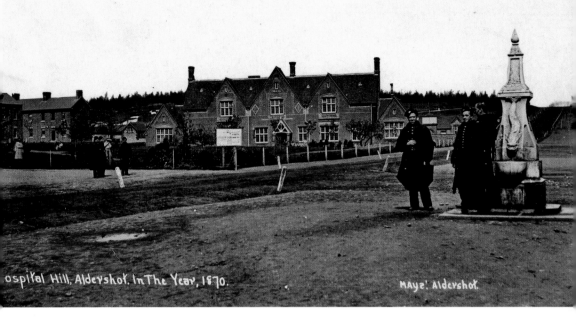

ospital Hill, Aldershot. In The Year, 1870.

MAYE' Aldershot.

Union Building

The building dates from 1629 and was originally a sub-manor to the Tichborne mansion in Aldershot Park. In the early nineteenth century it became a workhouse for the poor and then by 1851 it was a school for pauper children. The picture from 1870 shows the Union Building after the Army took it over for a hospital. Later it was the Garrison Pay Office and then a families centre, but today stands empty awaiting redevelopment into civilian apartments.

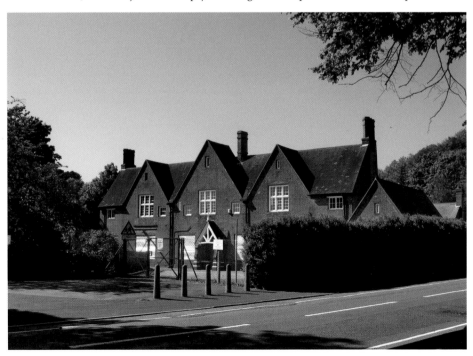

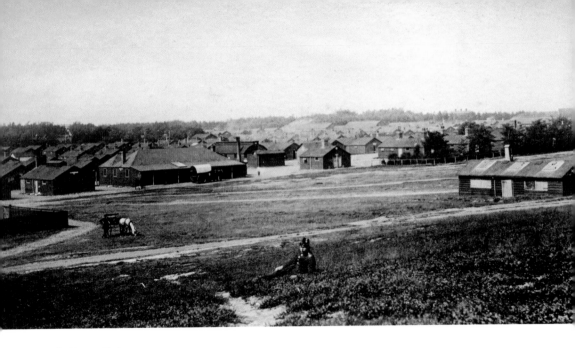

North Camp Huts

From 1854 the Army established two camps north and south of the Basingstoke Canal. All North Camp and most of South Camp consisted of wooden huts. The old photograph dates from 1883 and shows a typical battalion hutment; the larger building with the wagon outside is the canteen. In this area today are some of the most recent accommodation blocks; those in the photograph are for the new sergeants' mess.

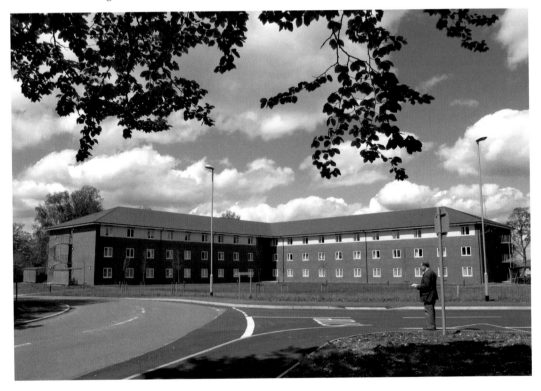

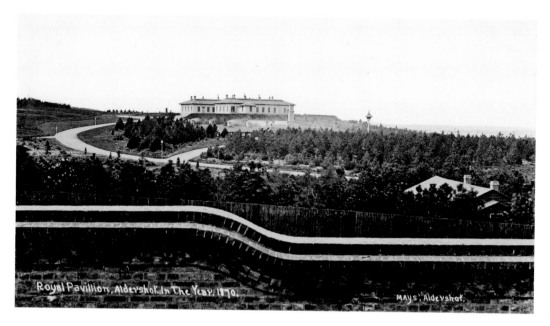

Royal Pavillion, Aldershot. In The Year, 1870.

MAYS', Aldershot.

The Royal Pavilion

Seen from the South Cavalry Barracks in the picture from 1870, the Royal Pavilion was a wooden bungalow built in 1856 for the royal family to use when visiting Aldershot. It was demolished in 1963 and the QARANC Training Centre built on the site, which in turn has been replaced by the Computer Sciences Corporation offices. The contemporary photograph shows the Royal Pavilion Guard Room, the only surviving wooden building from the early Camp.

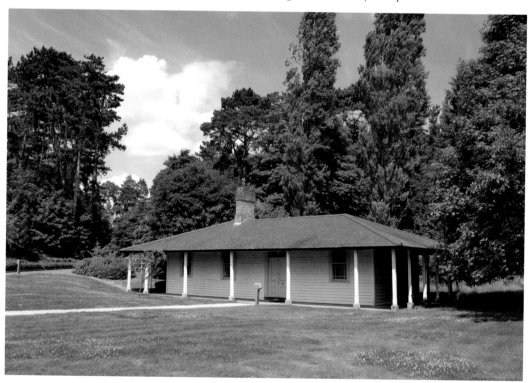

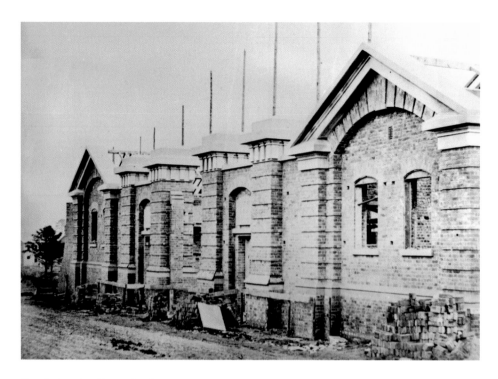

South Cavalry Barracks Gates

This remarkable early photograph shows the construction of the gates to the South Cavalry Barracks (later named Beaumont Barracks) in 1856. These were some of the first permanent barracks to be built in Aldershot. Although the barracks are gone the gates on the Farnborough Road still stand, along with the guardrooms behind, which are used by the Beaumont Park playgroup.

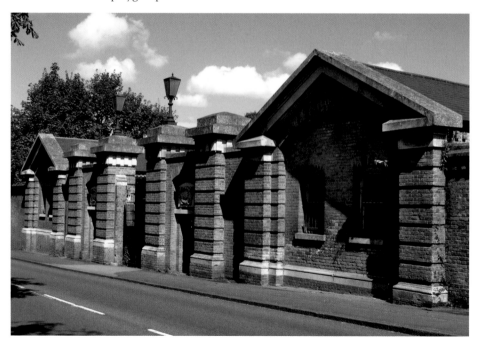

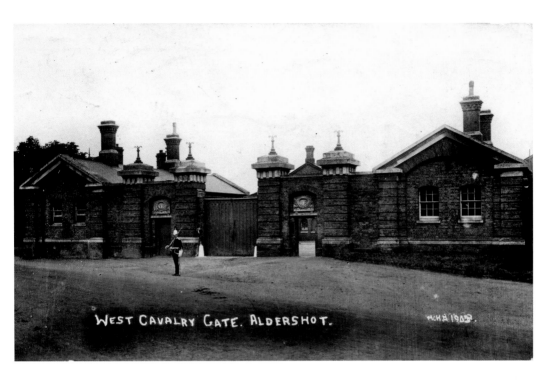

WEST CAVALRY GATE. ALDERSHOT.

West Cavalry Barracks Gates

Also built between 1856 and 1859, the West Cavalry Barracks (named Willems Barracks from 1909) also had its entrance onto the Farnborough Road. The Victorian barracks were demolished in the 1960s and nothing remains except for the gates on the roundabout at the Farnborough Road junction with Wellington Avenue. Behind the gates are the Willems Park pub and Travelodge hotel.

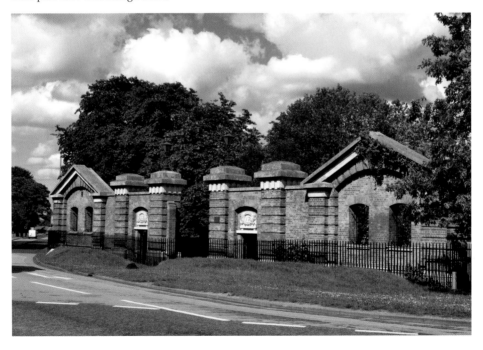

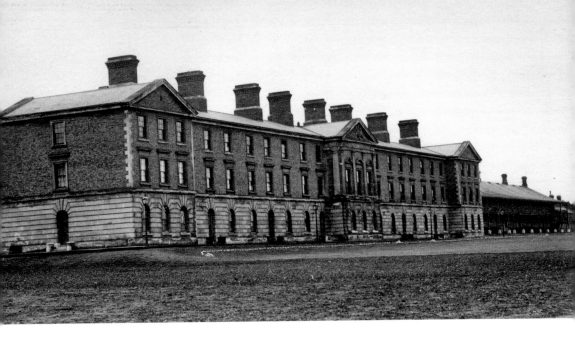

West Cavalry Barracks Officers' Mess
All the cavalry barracks were built to a similar pattern and the most imposing building was the large, elegant Officers' Mess, shown here in a photograph from 1883. Beyond the Mess can be seen one of the soldiers' blocks, with stables for the horses on the ground floor and the men's rooms above. Today the site is occupied by the Tesco superstore.

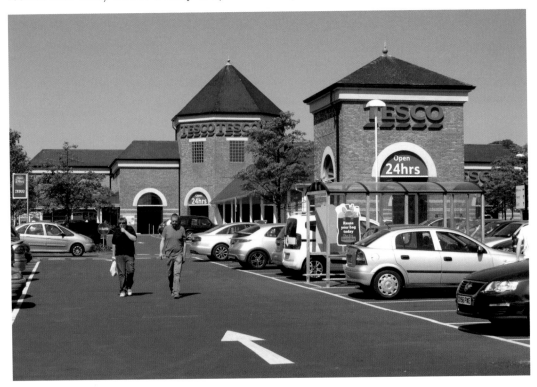

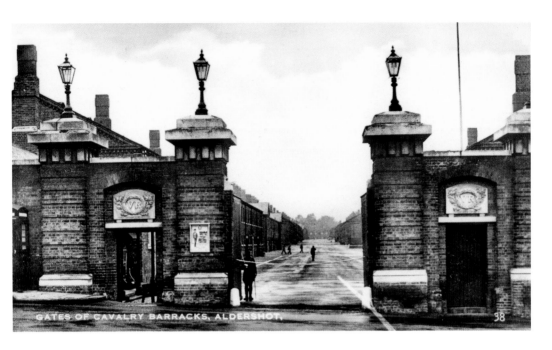

GATES OF CAVALRY BARRACKS, ALDERSHOT, 38

Warburg Cavalry Barracks Gates

The gates of Warburg Barracks (called the East Cavalry Barracks before 1909) were opposite the top of the High Street, showing how close were military and civilian Aldershot. The picture from around 1929 shows the view through the gates; the lines of buildings and the straight road leading through to Willems Barracks. Warburg Barracks were completely demolished in the 1960s and part of the site is the new Westgate centre, pictured under construction in summer 2012.

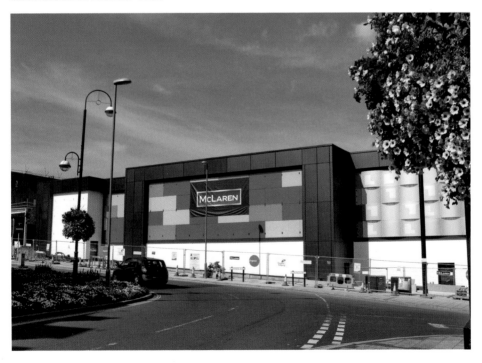

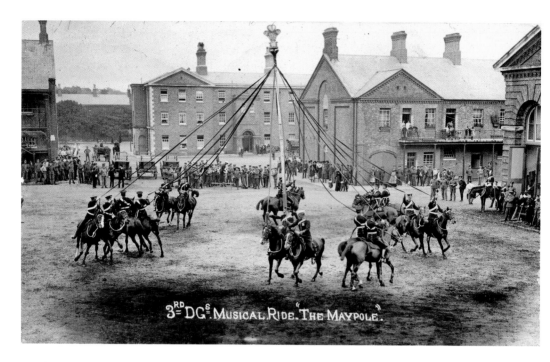

Warburg Cavalry Barracks

An interesting view of the buildings inside Warburg Barracks, where men of the 3rd Dragoon Guards are performing their 'Maypole' musical ride, *c.* 1910. After the demolition of Warburg in the 1960s part of the area was used for the Princes Hall theatre, in the foreground of the modern picture, and behind it the police station.

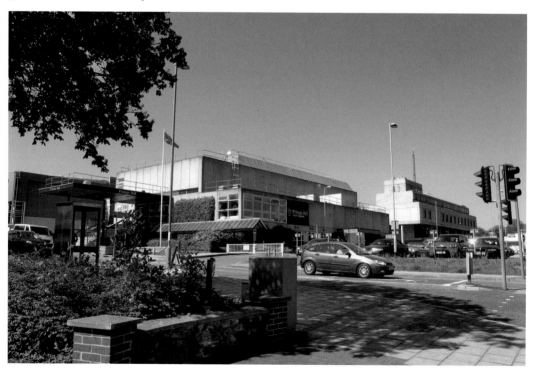

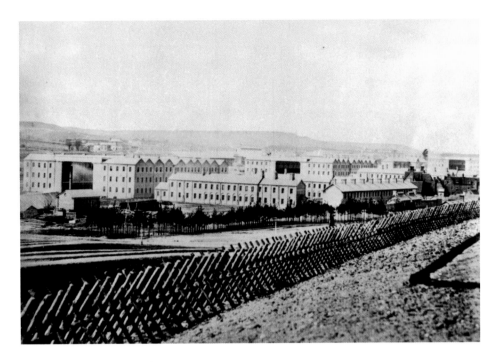

The First Infantry Barracks

Also built between 1856 and 1859 were three infantry barracks, called East, Centre and West blocks until renamed Badajos, Salamanca and Talavera in 1898. The old photograph is from 1860 and is an early view of the newly completed barracks. All were demolished after the Second World War and the view from a similar position today shows the modern married quarters of Salamanca Park.

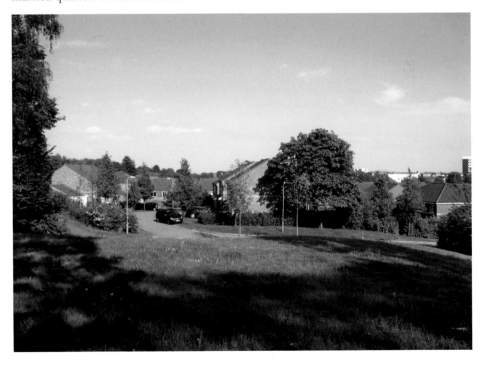

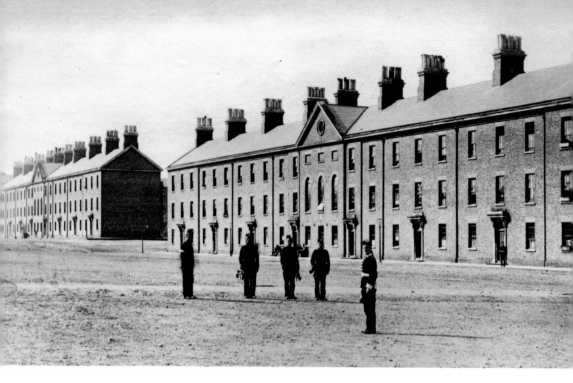

Infantry Barracks Officers' Quarters

The photograph from 1883 shows the Officers' Quarters for West and Centre Infantry Barracks (later named Badajos and Salamanca Barracks). In the centre of each building, under the pediment, was a large mess room with the officers' private quarters in houses on either side, each one accommodating eight officers and four servants. On the site today are the modern houses of Salamanca Park married quarters.

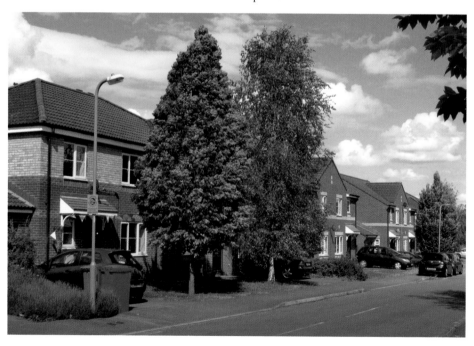

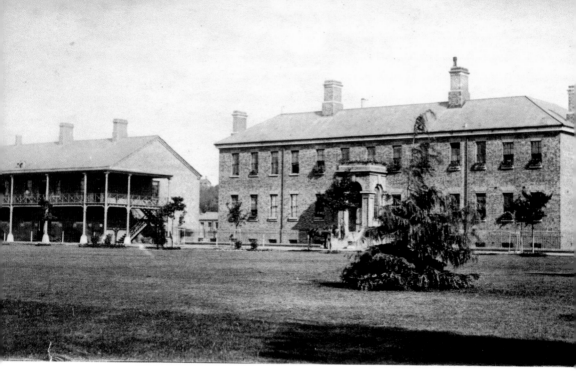

Royal Artillery Barracks

The 1850s permanent barracks included two artillery barracks, one for foot and the other for horse artillery. The photograph from 1883 shows the Horse Artillery Barracks Officers' Mess on the right and one of the blocks of troops' accommodations and stables on the left, in a similar style to the cavalry barracks. Renamed in 1898 Waterloo Barracks East and West, they were demolished in 1958–59 and replaced by the married quarters shown in the modern photograph.

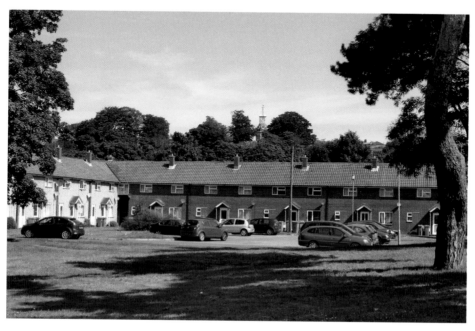

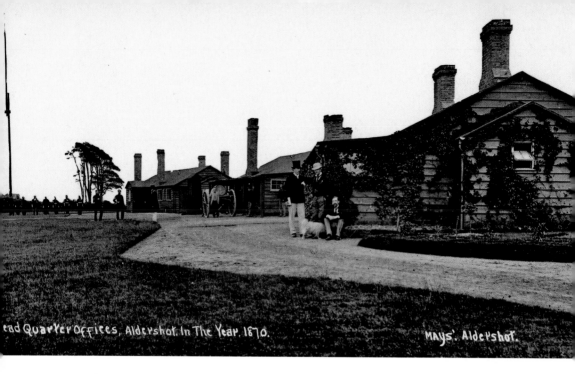

ead Quarter Offices, Aldershot. In The Year. 1870. MAYS'. Aldershot.

Garrison Headquarters

Despite the line of brick barracks built along the south of the Camp in the 1850s, the majority of the garrison remained in wooden huts. As shown in the photograph of 1870, even the Garrison Headquarters were in huts, sited along the ridge of Stannon Hill, today the line of Hospital Road. On the site is the old Garrison Officers' Mess built in the 1960s but now empty and due for demolition.

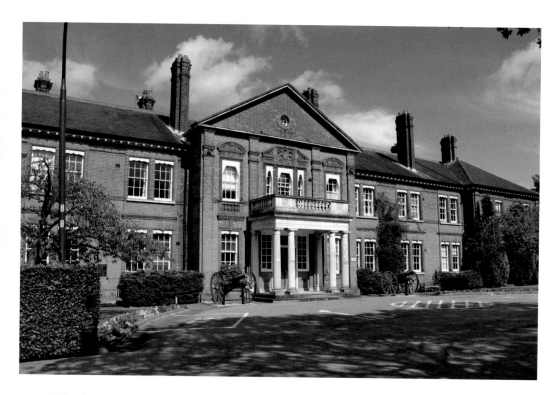

Aldershot Command Headquarters

By the end of the nineteenth century Aldershot Command had been established, taking in Aldershot Garrison itself and barracks throughout the surrounding area. In 1894–95 an elegant new Command Headquarters was built. The top photograph shows the building today, largely unchanged from when it was built and now headquarters of the Army Support Command. The lower picture is from around 1939, when much of the architectural detail was hidden by ivy.

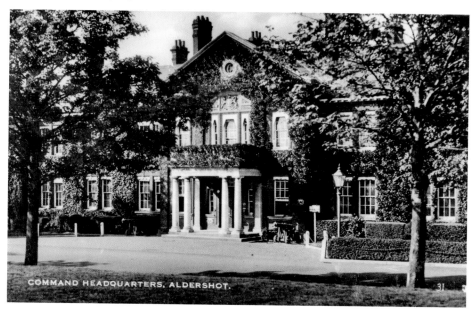

COMMAND HEADQUARTERS, ALDERSHOT.

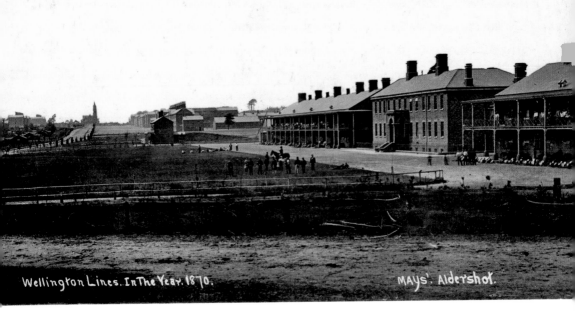

Wellington Lines. In The Year. 1870. MAYS'. Aldershot.

Wellington Avenue

It is difficult today to appreciate how open Aldershot was in the early days of the Camp. The photograph from 1870 shows the view looking east along what would become Wellington Avenue. On the right are the Artillery Barracks, then the Infantry Barracks, and the garrison church is clearly visible on the horizon. In the modern view the space is filled with buildings and trees, but the church spire can still be seen in the distance.

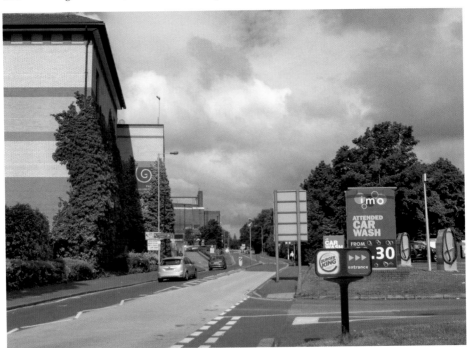

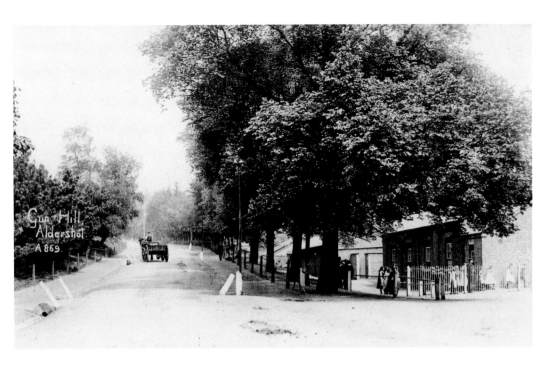

Gun Hill

Leading from Wellington Avenue to Hospital Road, Gun Hill takes its name from the Time Gun which was sited at the top of the hill in the early years of the Camp. The old photograph dates from around 1910 and some buildings of Waterloo Barracks East can be seen on the right. The modern view is remarkably similar, except that the 1890s barrack buildings have been replaced by 1960s married quarters houses.

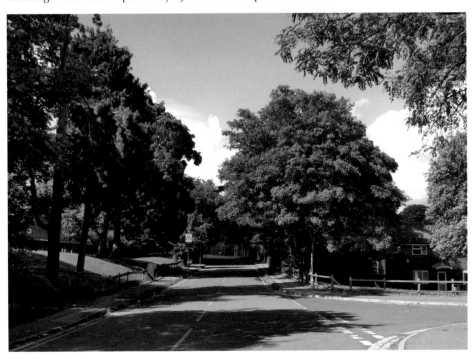

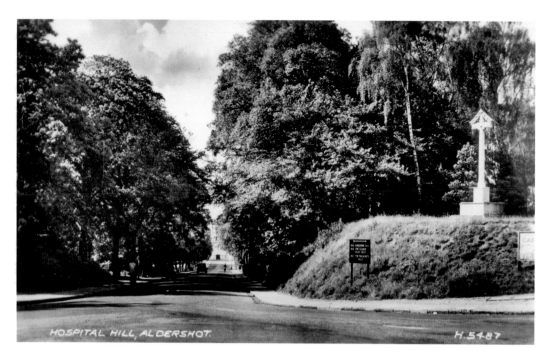

HOSPITAL HILL, ALDERSHOT. H.5487

Hospital Hill

The road takes its name from the hospital in Union Building, which is behind the trees on the right in these pictures. The memorial on the mound in the right foreground is to the men of 2nd Division who fell in the First World War and was unveiled on 1 December 1923. There is little change between the view in the photograph from 1949 and that of today.

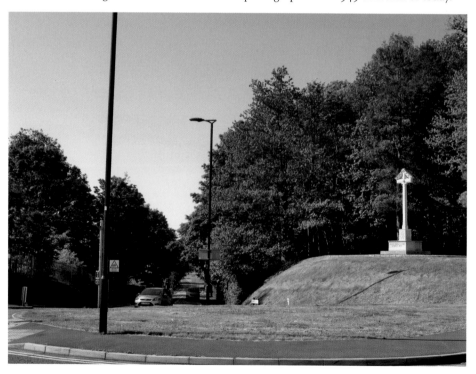

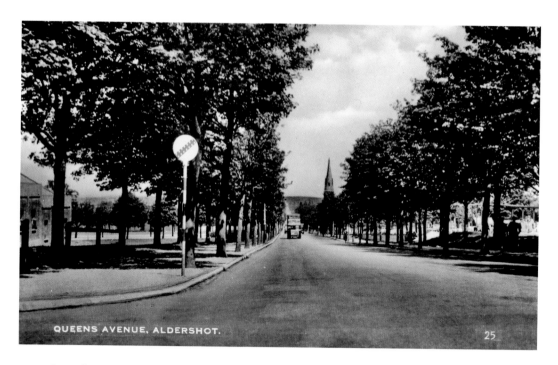

QUEENS AVENUE, ALDERSHOT.

25

Queen's Avenue

The main road running through the garrison from north to south was named Queen's Avenue in 1898 by command of Queen Victoria, following a particularly successful royal review of the garrison. The trees were planted in the late nineteenth century and have matured to give a most elegant avenue. The scene in the photograph from the 1930s is still easily recognisable today, with the spire of the church of St Michael and St George a clear landmark.

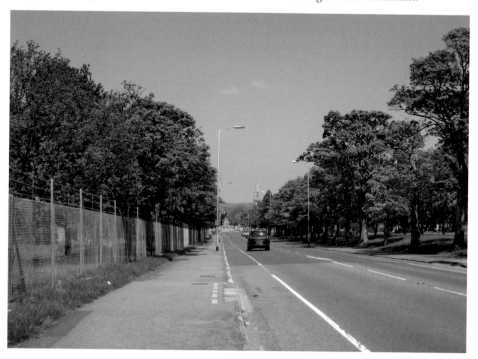

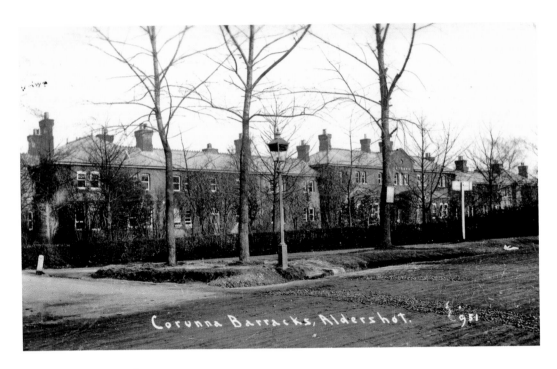

Corunna Barracks, Aldershot. 1951

Corunna Barracks

Between 1890 and 1895 the wooden huts were finally replaced with brick barracks throughout the Camp. Corunna Barracks, pictured around 1912, was one of the many infantry barracks in South Camp. After the Second World War they were demolished and new concrete barracks built for the Airborne Forces, so Corunna became Arnhem Barracks within the new Montgomery Lines. These 1960s blocks are now empty and will be demolished to be replaced with civilian housing.

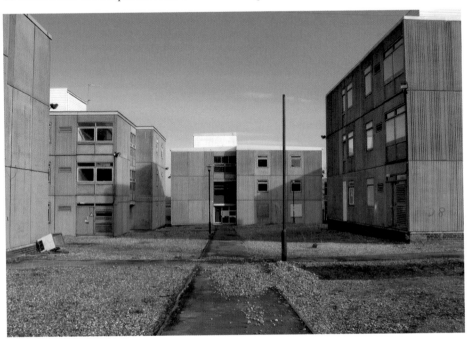

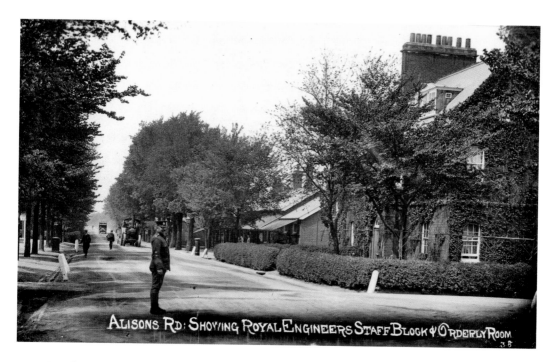

ALISONS RD: SHOWING ROYAL ENGINEERS STAFF BLOCK & ORDERLY ROOM

Royal Engineers Barracks

In the 1890s rebuild the Royal Engineers were housed in Gibraltar Barracks, on the north of Alison's Road. The older photograph dates from around 1910; note the steam traction engine in the road. After the Second World War the Royal Engineers moved to Minley. Gibraltar Barracks was demolished and replaced with Browning Barracks, the depot of the Airborne Forces. As seen in the modern picture, these are also now empty and scheduled for redevelopment as civilian housing.

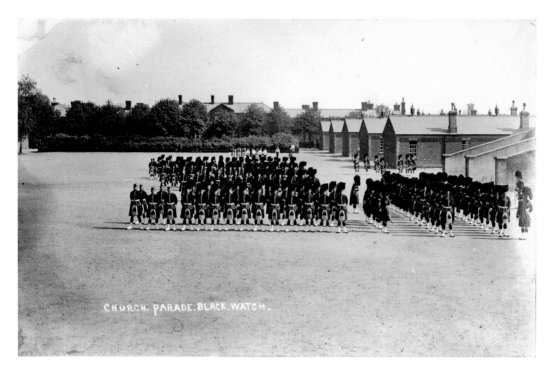

CHURCH. PARADE. BLACK. WATCH.

Oudenarde Barracks

The North Camp wooden huts were replaced with single-storey barrack blocks, one per company (approximately thirty men). Oudenarde Barracks was one of a series of infantry barracks which made up Marlborough Lines. The historic photograph shows the Black Watch parading in 1913, with soldiers' barracks on the right and the Officers' Mess behind. Only two of the Victorian barracks blocks remain, now used for the Aldershot Military Museum, shown in the modern picture.

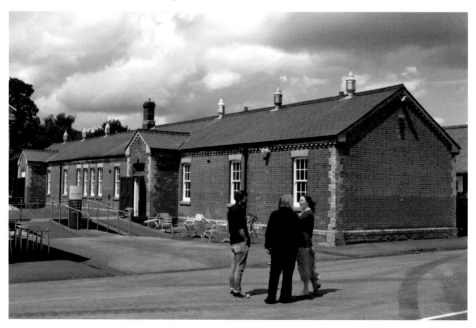

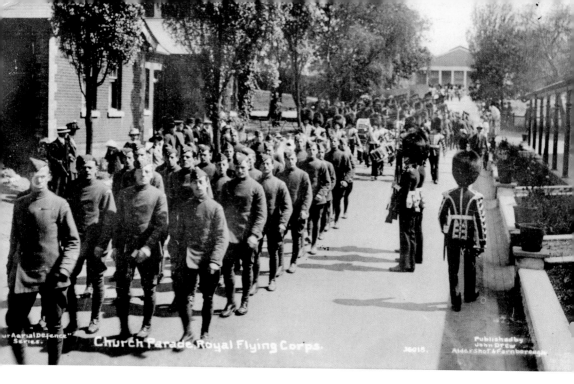

Church Parade, Royal Flying Corps.

Evelyn Wood's Road

The old photograph shows the Royal Flying Corps around 1913 marching back from the North Camp church, visible at the end of Evelyn Wood's Road. They are followed by a Guards band in full dress. The road still exists but the church and the other Victorian buildings were demolished in the 1960s reconstruction. In the right foreground of the modern view is the Boyce Building of the Aldershot Military Museum and the barrier marks the entrance to Normandy Barracks.

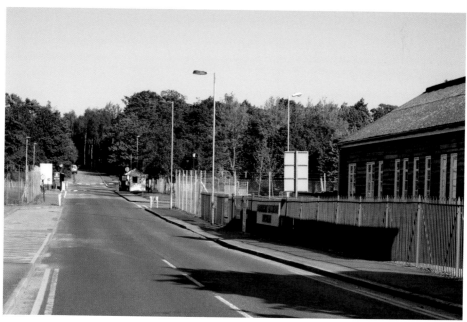

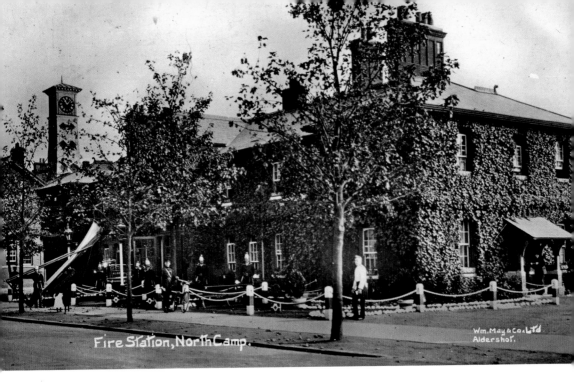

Fire Station, North Camp.

Wm. May & Co. Ltd
Aldershot.

Clocktower School and Fire Station

There were fire stations in both north and south camps, each with a fully equipped fire brigade. In the photograph from 1910 the men of the North Camp brigade pose outside the station in their polished brass helmets. Behind is the clock tower of the North Camp infants school. This building still stands and is used for a playgroup, but the fire station is no more and its site is just an open space.

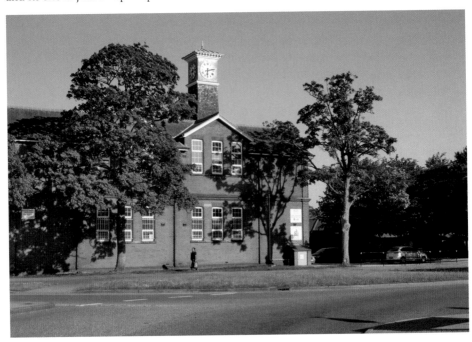

St Omer Barracks

The most famous of the post-war military buildings was probably the tower of St Omer Barracks, opened in 1971. Housing the training centre for the Army Catering Corps, the tower could be seen for many miles around. St Omer Barracks was the first site in the latest redevelopment and was entirely demolished. The second photograph shows soldiers of the Royal Logistic Corps parading for the handover of the first of the new accommodation blocks in June 2008.

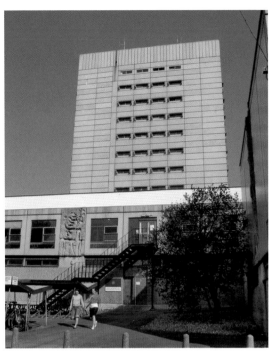

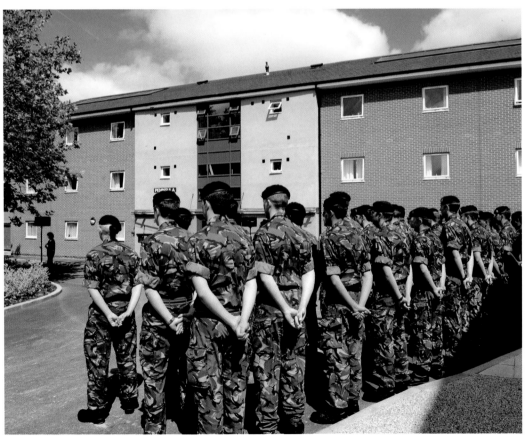

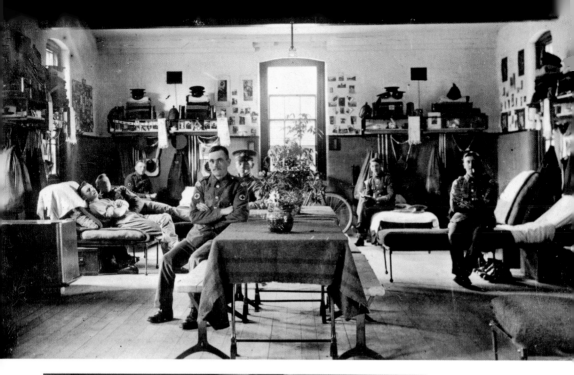

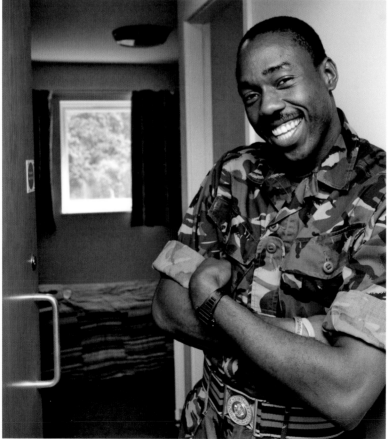

Soldiers' Accommodation
These two photographs show how much soldiers' living quarters have improved. The first dates from 1911 and shows a typical barrack room, in this case RAMC personnel in McGrigor Barracks. Note how little space each man has in the shared barrack room. In the modern accommodation blocks single soldiers have their own rooms, to the evident pleasure of this soldier from 27 Regiment RLC in his new barracks.

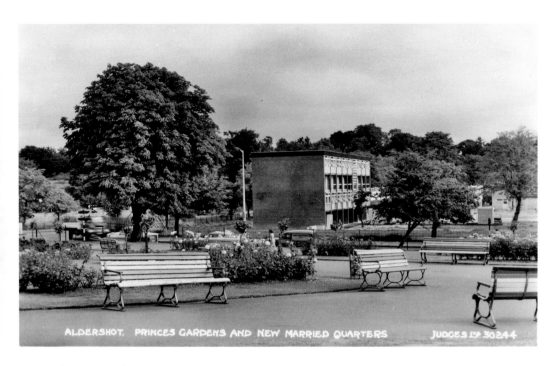

ALDERSHOT, PRINCES GARDENS AND NEW MARRIED QUARTERS JUDGES L™ 30244

Talavera Married Quarters

When the Victorian Talavera Infantry Barracks were demolished they were replaced in the 1960s by blocks of flats for married quarters, seen in this view across Wellington Avenue from Princes Gardens. However, these were poorly built and rapidly deteriorated, so they were replaced in the 1990s by new quarters built more traditionally. These can just be seen from a similar position, screened now from the road by trees and bushes.

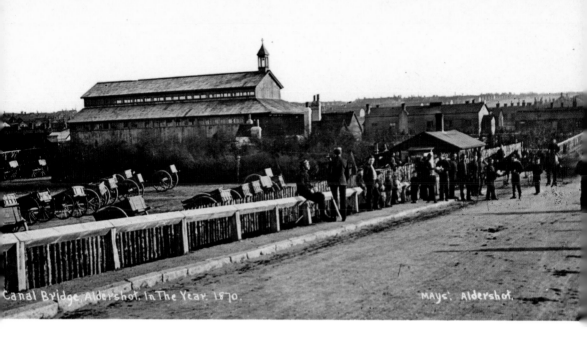

Canal Bridge, Aldershot. In The Year. 1870. MAYs'. Aldershot.

The Iron Church

The photograph from 1870 is taken from the old Wooden Bridge over the Basingstoke Canal and looks over to the Iron Church, so named because its wooden walls were hung on an iron frame and it had a tin roof with iron pillars. This was the first garrison church, originally sited near Thorn Hill and moved to this location in 1866. It was dismantled in 1926 and St Andrew's church, the garrison church of Scotland, was built on the site.

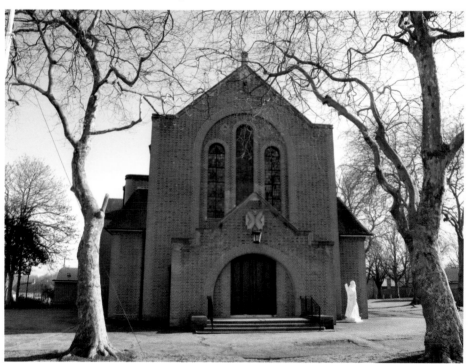

Royal Garrison Church of All Saints

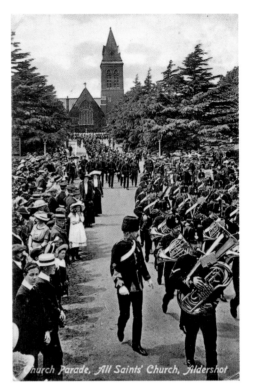

A suitable garrison church was needed for the Camp, so the church of All Saints was built west of the Farnborough Road and dedicated on 29 July 1863. The church was granted the title 'Royal' by King George V in 1923, in recognition of its Diamond Jubilee. The early photograph, c. 1912, shows crowds watching one of the regular Sunday church parades. The church itself is little changed to the present day, but church parades are now rare events.

Church Parade, All Saints' Church, Aldershot

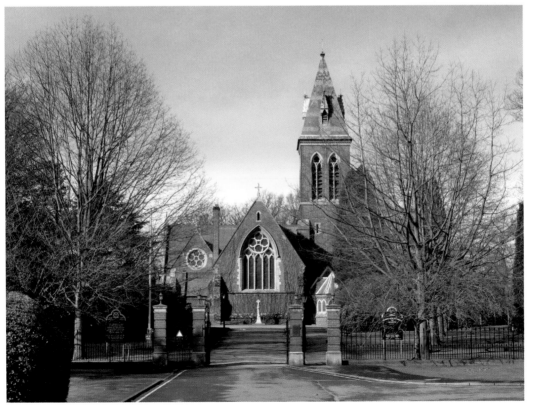

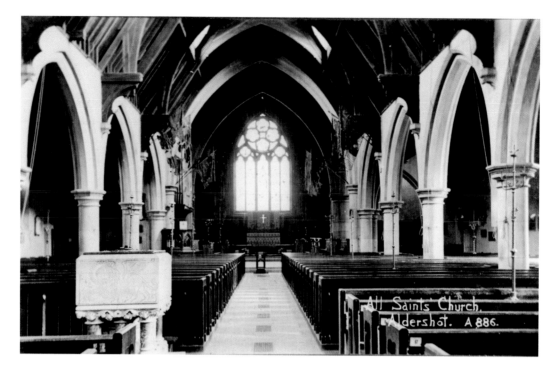

Interior of the Royal Garrison Church

Although the main structure is the same, there are a number of detailed changes between these photographs from before the First World War and the present day. In the modern picture note the memorial panels under the main window to the 172 Royal Army Chaplains who died in the Great War, the modern altar painting, the font cover donated by 16 Independent Parachute Brigade in 1957, and the addition of central heating.

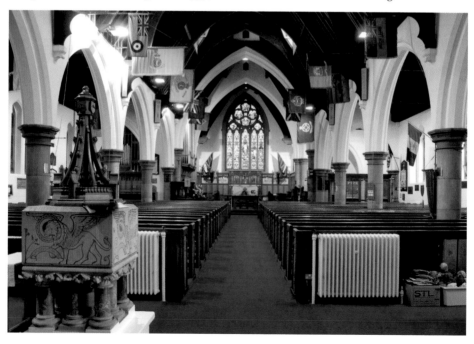

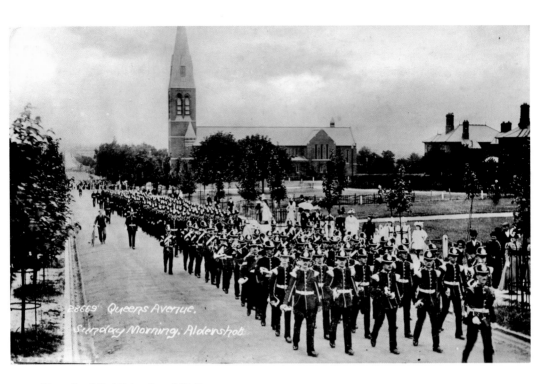

28669 Queens Avenue. Sunday Morning. Aldershot.

Church of St Michael and St George

When the garrison was rebuilt in the 1890s another church was built to cope with the growing numbers of soldiers. Queen Victoria laid the foundation stone for the church of St George in 1892, and the older photograph shows a church parade from 1912. From 1973 the church has been the Roman Catholic garrison church and named St Michael and St George. It is also the cathedral church of the Roman Catholic Bishop of the Forces.

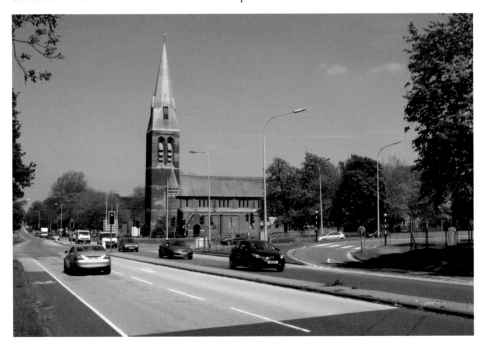

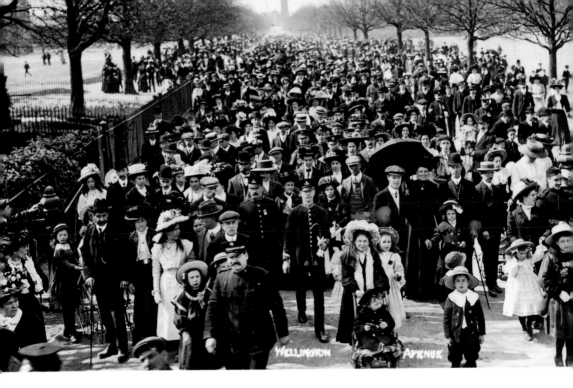

Sunday in Wellington Avenue

The colourful Sunday church parades drew hundreds of spectators, especially to Wellington Avenue. After the parade people enjoyed walking in the Avenue, which was a broad, elegant thoroughfare leading from the garrison church past the barracks of Wellington Lines. In the 1960s Wellington Avenue was diverted from the Hospital Hill junction, and the section leading to the church was cut off. In the modern photograph Tesco's superstore can be seen behind the trees on the left.

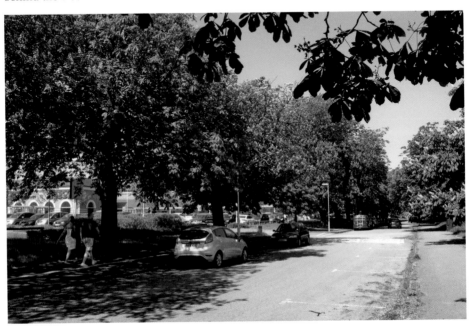

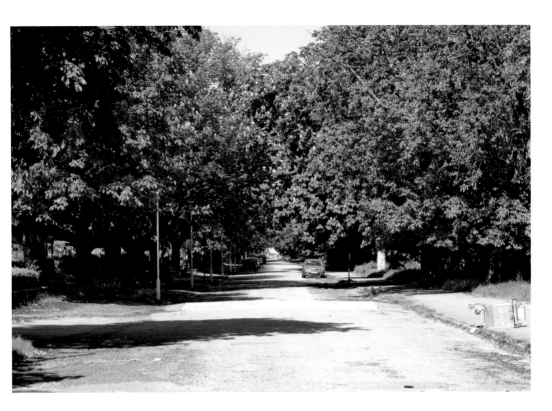

Willems Avenue

Not only was Wellington Avenue cut off at Hospital Hill in the 1960s, the junction with the Farnborough Road was also closed so the western section is only accessible via the Tesco car park. Renamed Willems Avenue, it is now largely deserted except for the occasional parked car and learner driver, a very different scene from the days when full dress cavalry could be seen regularly riding down the avenue, such as these 21st Lancers pictured around 1908.

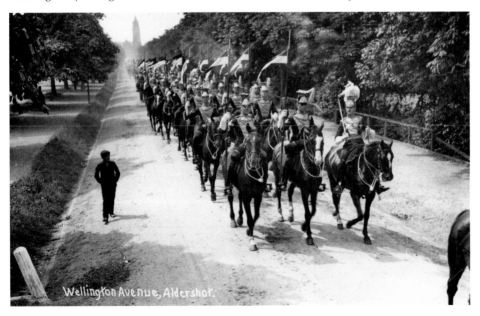

Wellington Avenue, Aldershot.

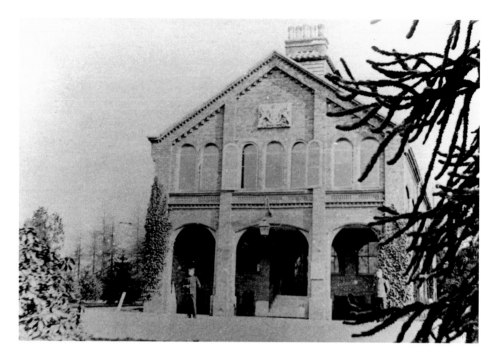

The Prince Consort's Library

Opened in 1860, this was founded by the Prince Consort as a military library for Aldershot. In the photograph from the 1870s the first librarian, Sergeant Charles Gilmore, stands on the left with his orderly on the right. In the modern view the current librarian Tim Ward takes the place of Gilmore, with library assistant Robert Tilley on the right. This picture also shows the extension, on the left, built in 1911.

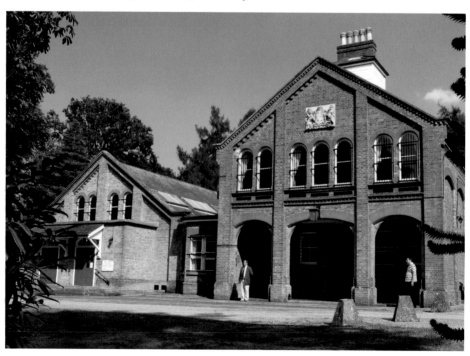

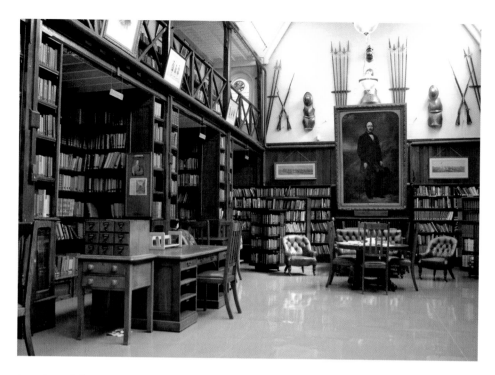

Interior of the Prince Consort's Library

Although much of the present-day work of the library is concerned with digital information delivered online to Army personnel around the world, the outstanding book collection remains important. The historical library is still remarkably original, as can be seen by comparing the modern top photograph with that of the Victorian interior below, showing that not only is the structure still intact but also much of the original furniture is still in use today.

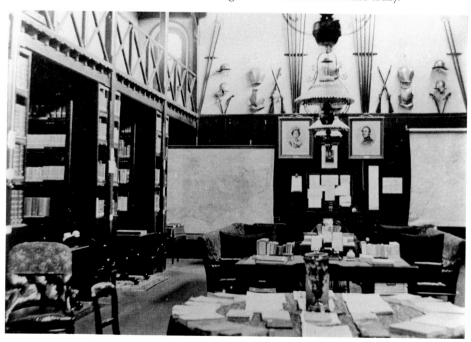

The First Gymnasium

In 1860 Major Frederick Hammersley and twelve staff formed the Army gymastic staff in Aldershot, which grew into the Royal Army Physical Training Corps. The old photograph from 1883 shows the original gymnasium which stood behind the infantry barracks of Wellington Lines and was the first gym to be built for the British Army. Below is the most recent, the Physical and Recreational Training Centre in St Omer Barracks opened in 2010.

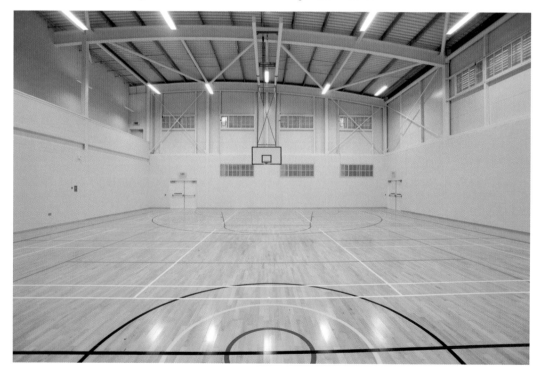

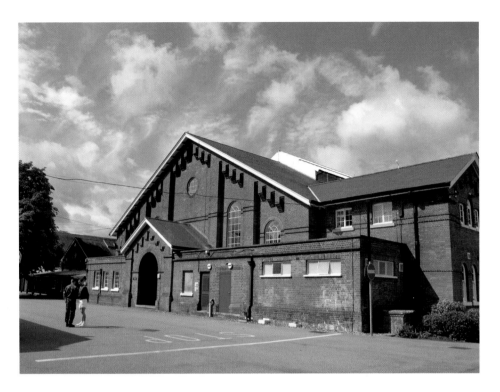

The Fox Gymnasium

In 1894 a new and much larger gymnasium, shown in the top picture, was built at the instigation of Colonel Malcolm Fox, Inspector of Gymnasia from 1890 to 1897. This is within the Army School of Physical Training and is still in use today. The photograph below shows the interior of the gym with the NCOs who were passing out as PT instructors in 1918, carefully posed to show off their skills.

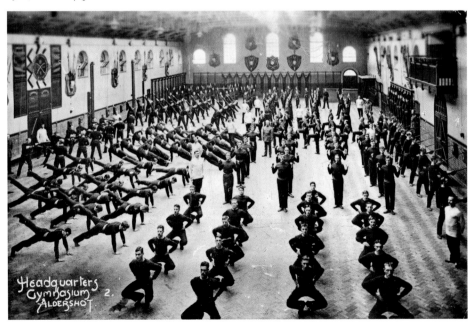

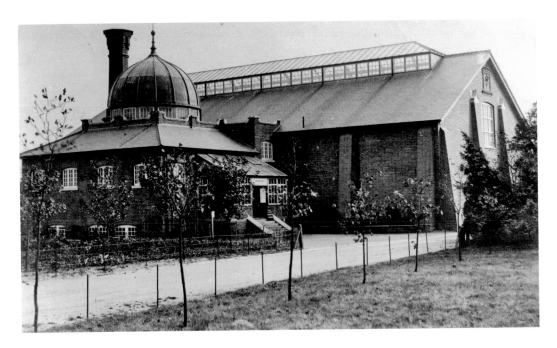

The Command Swimming Baths

Built next to the Fox Gym, the Command Swimming Baths were opened in 1900 by Fox's successor, Colonel John Scott Napier. The building has stopped being used as a swimming bath since a new modern garrison pool was built, and it is currently awaiting a decision on its future use.

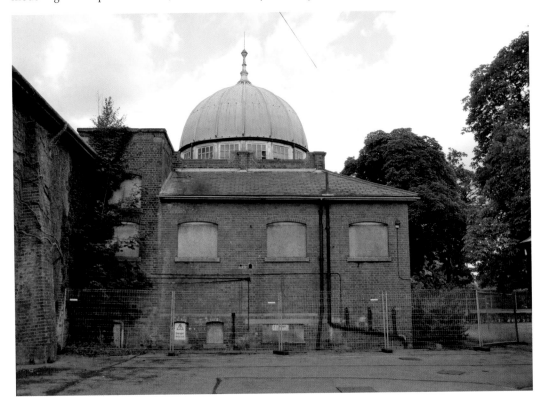

The Cambridge Hospital

Named after the Duke of Cambridge, Commander-in-Chief of the Army, the Cambridge Military Hospital opened in 1879. The clock-tower is 109 feet high, and the dials of the clock are 8 feet in diameter. The Cambridge closed in 1996 and military patients are now treated at Frimley Park NHS hospital. The building has stood empty since closure, but under the Aldershot Urban Extension it is expected to be used for civilian residential apartments.

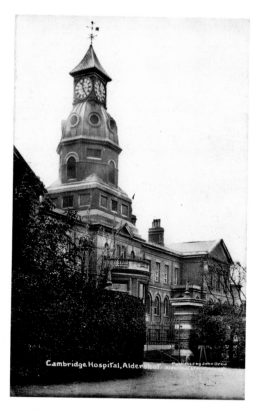

Cambridge Hospital, Aldershot. Published by John Drew

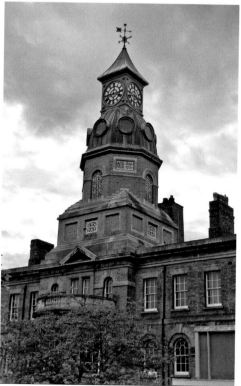

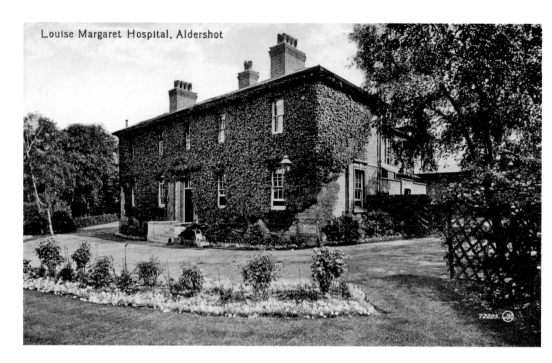

Louise Margaret Hospital, Aldershot

The Louise Margaret Hospital

In 1897 HRH Princess Louise Margaret, Duchess of Connaught and Strathearn (wife of the Duke of Connaught who was General Officer Commanding in Aldershot), laid the foundation stone of a smaller hospital to the east of the Cambridge, for the wives and children of the garrison. It continued as a maternity hospital until its closure in January 1995. The building currently stands empty, awaiting redevelopment.

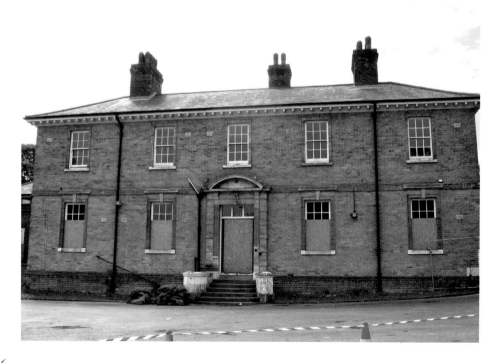

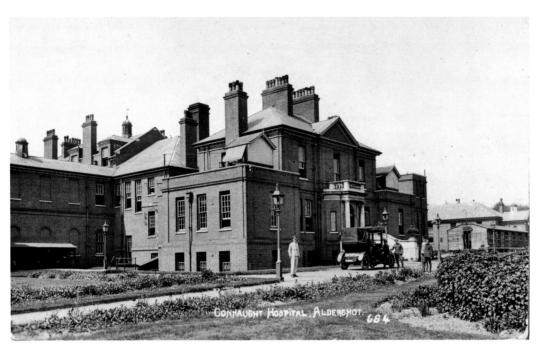

The top photograph shows the Connaught Hospital in the 1920s.

The Connaught Hospital

The top photograph shows the Connaught Hospital in the 1920s. This was another large military hospital, opened in 1898 in North Camp and named after the Duke of Connaught. It treated casualties from both world wars, but was closed in 1946 and used as offices. Most of the building was demolished in the late 1980s but the central entrance block was retained and is now used as the entrance to the Normandy Barracks Mess.

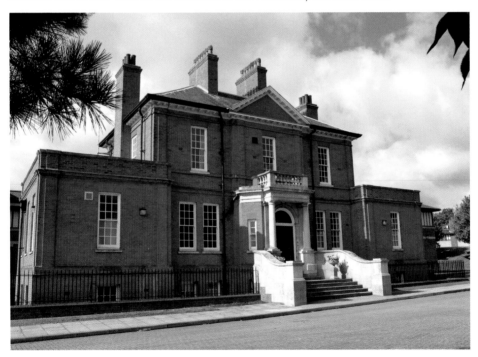

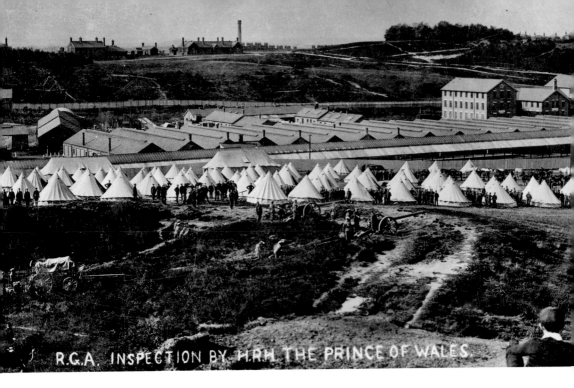

R.G.A. INSPECTION BY H.R.H. THE PRINCE OF WALES.

The Redan

The Redan fort was built in the 1850s to defend the Camp from the south-east. The top photograph is the inspection of the battery in 1906 by the Prince of Wales (later King George V), and shows the view over the huge Field Stores and across to Peaked Hill. Parts of the Redan were restored by Rushmoor Council in 1990 but, as shown in the modern picture, the hill is now so thickly wooded that the views are lost.

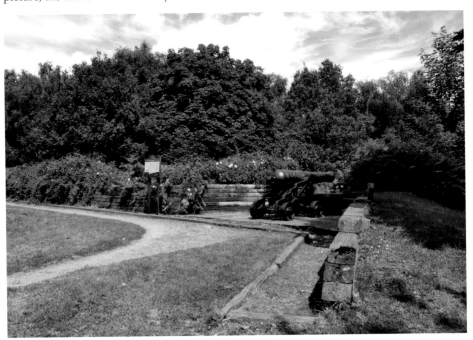

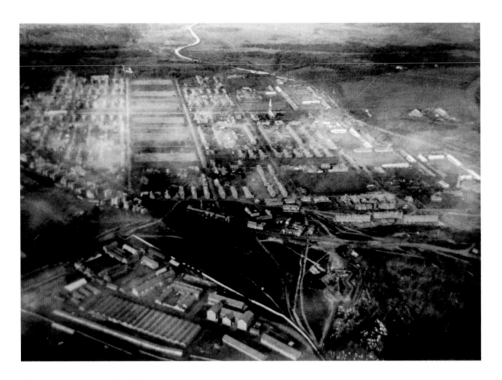

The Camp from the Air

This rare old photograph dates from around 1912 and was taken by aviation pioneer Samuel Cody. In the lower foreground are the Field Stores, across the middle are the barracks of Stanhope Lines, and in the centre is St George's church. In the modern aerial photograph the new St Omer Barracks is in the foreground, the Basingstoke Canal is on the right, and the church of St Michael and St George is top right.

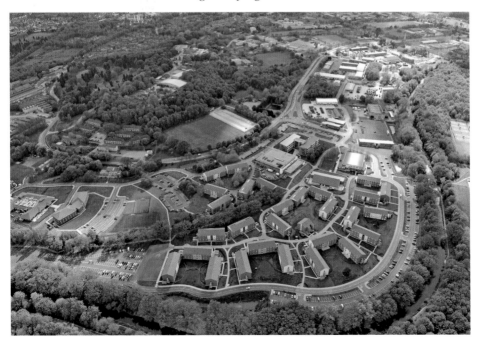

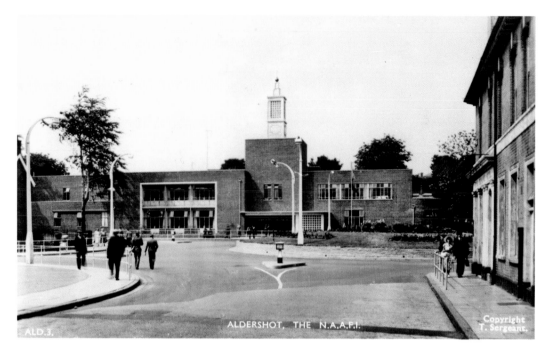

The NAAFI Roundabout

The older photograph was taken around 1950, looking from Station Road to the large NAAFI Club which was opened in 1948, built on the site of the old guardroom of Waterloo Barracks West. On the right is the Royal Exchange Hotel, this building dating from 1873. The Royal Exchange closed in 2001 and was converted into flats. The NAAFI Club closed in 1971 and was demolished in the 1980s; on the site today is Burger King.

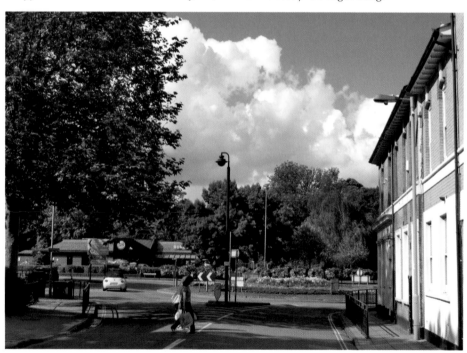

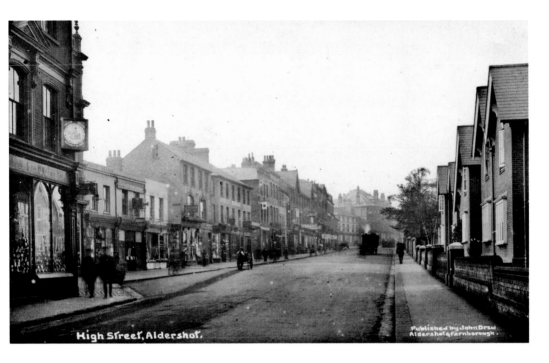

High Street, Aldershot.

Published by John Drew
Aldershot & Farnborough.

High Street from the Station Road Junction

The view looking up High Street in the early years of the twentieth century shows the Victorian shops on the left, and on the right are the old police houses. Note the steam engine coming down the street. In the modern photograph the Victorian shops are interrupted by the Galleries shopping centre, and on the site of the police houses is a multi-storey car park.

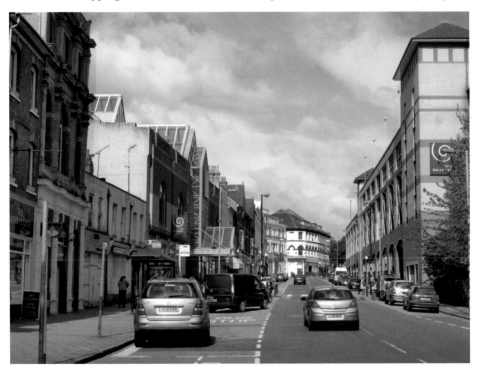

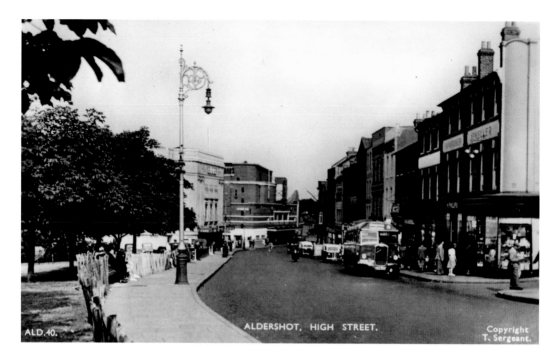

ALDERSHOT, HIGH STREET.

ALD.40.

Copyright
T. Sergeant.

High Street from Princes Gardens

Although separated by nearly sixty years, these views of the upper High Street show how little has changed. On the left in both photographs is Princes Gardens and the Empire and Ritz Cinema buildings, although these are now respectively the King's church and Gala Bingo. The buildings on the right are largely unchanged except for the shop windows and proprietors, and even the bus stops are in the same location.

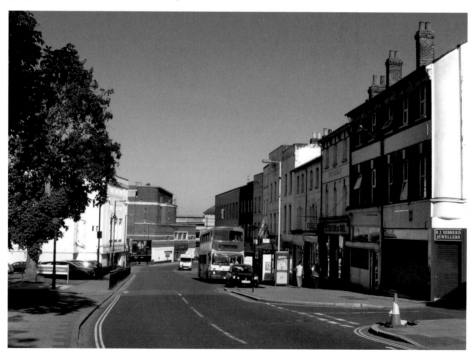

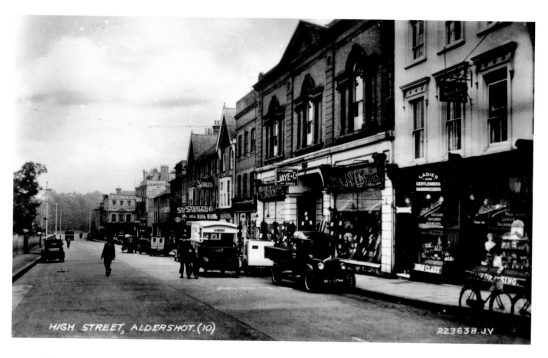

The Market Arcade Entrance on High Street

In 1914, Park and Sparkhall opened an arcade on the site of the old Aldershot Market. It led from their shop in Wellington Street to High Street, and the arched entrance is clear in the upper view from 1937. The building is now Bridges estate agents. The top of the entrance is still visible over the new shop window, and the elegant decoration around the upper-storey windows remains intact.

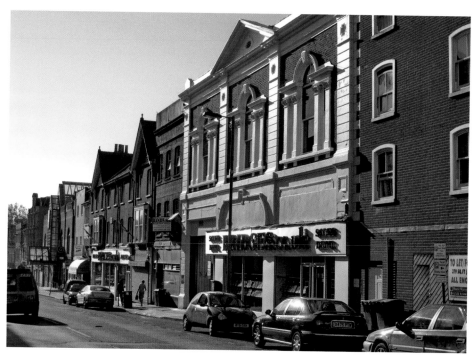

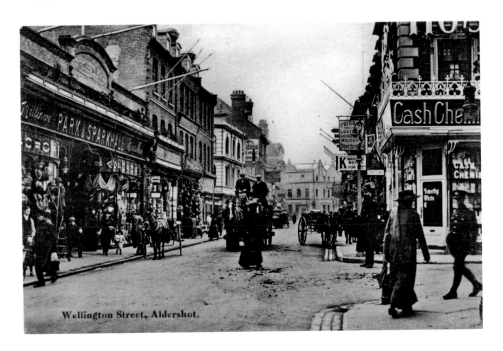

Wellington Street, Aldershot,

Wellington Street

On the left in this photograph from around 1920 is the premises of Park and Sparkhall Milliners and Costumers and the Wellington Street entrance to the Market Arcade; opposite is Timothy White and Taylors 'cash chemists'. In the contemporary view there are modern shop buildings on the left. White's shop is now Costa Coffee, and further down the street the view through to Victoria Road is blocked by the bridge between the Wellington Centre and the Galleries.

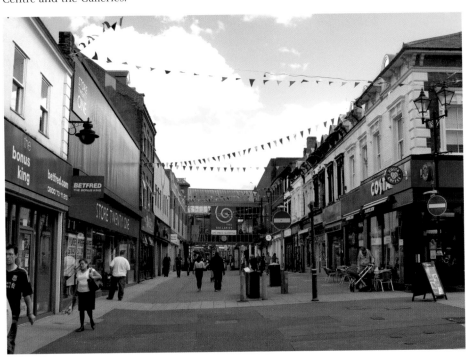

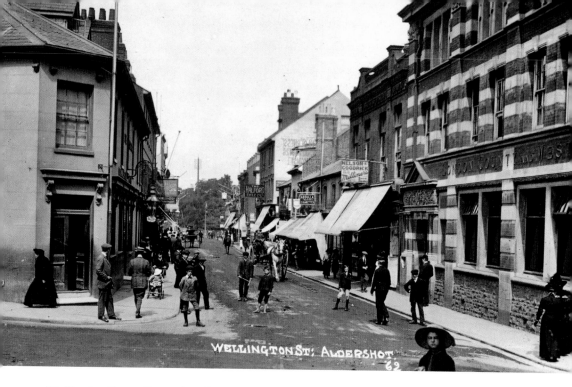

Wellington Street from Victoria Road

In the Edwardian view of Wellington Street the George Hotel is on the left and the London County and Westminster Bank on the right, beyond that are milliners Nelson and Goodrich and the entrance to the old arcade. The George Hotel is now the Goose pub, the bank is the NatWest, and the old arcade and associated shops have been replaced by a modern pastiche built in the 1990s.

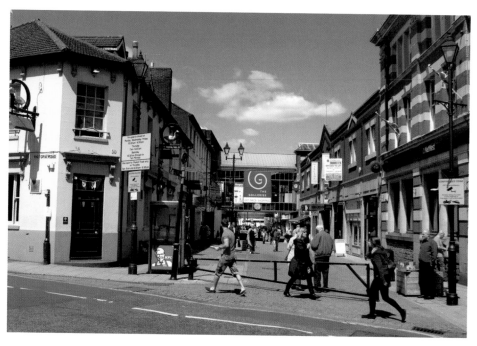

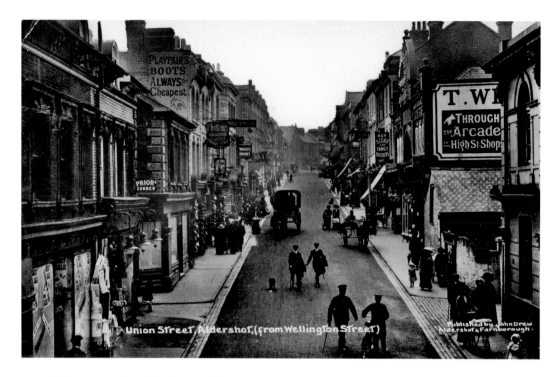

Union Street from Wellington Street

In the 1870s Union Street was developed along with the High Street as the commercial centre of the town, with a mixture of shops and public houses. The top photograph shows the view looking up from Wellington Street around 1914. Many buildings have been replaced over the years so the scene today looks very different.

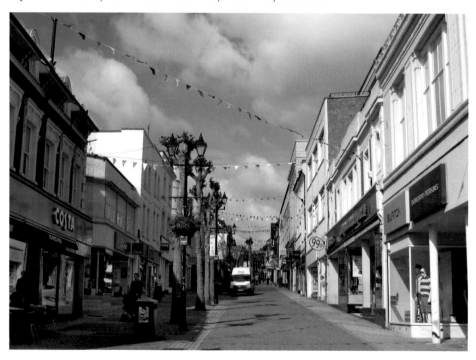

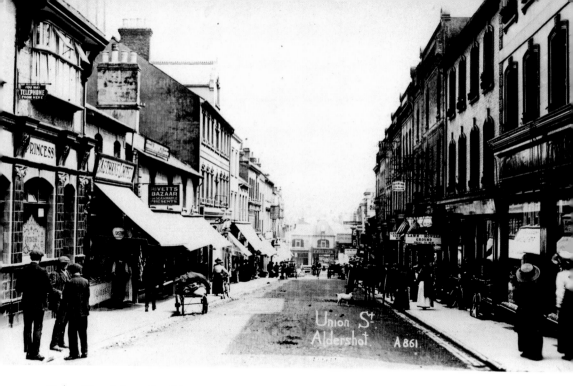

Union Street from the Princess

These views are looking in the opposite direction from those on the previous page. The older photograph dates from around 1915 and on the left is the Princess pub, which was rebuilt with its mock-Tudor gables in 1907–08. Beyond is Eastman's Cleaners and Rivett's Bazaar, while on the right is the Junior Army and Navy Stores. Today Union Street remains a main shopping street, but the Princess is now the Halifax Building Society and opposite is KFC.

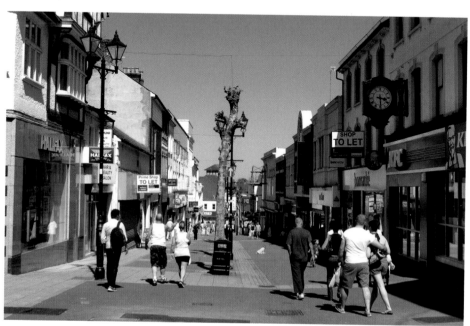

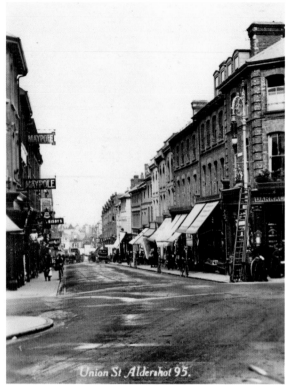

Union Street from Grosvenor Road
Another pair of contrasting views
looking down Union Street from
Grosvenor Road in the 1920s and in
the modern day. On the right in the
older picture is Darracott's bakery,
which was replaced by Court's
furniture store which in turn has
been replaced by a new building of
residential flats. Clearly shown in the
modern photograph is the line of trees
planted down the centre of the road
when it was made a pedestrian zone.

The Methodist Church

The fine Methodist church on the corner of Grosvenor Road and Queen's Road was built in 1874 at a cost of £10,000, and its 100-foot-high tower is a local landmark. Although the building appears largely unchanged externally, it is no longer used for worship but for purposes as diverse as music studios, accountants offices, and a dental surgery. The conversion won the Rushmoor Civic Design Award in 1992, commemorated in the stone behind the sign.

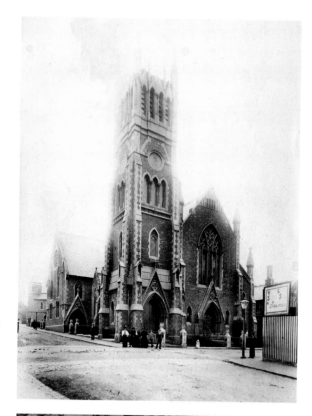

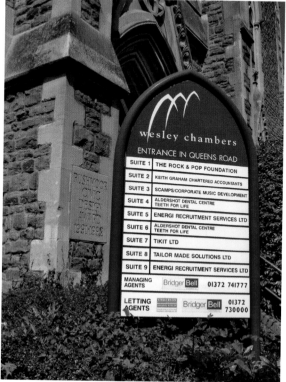

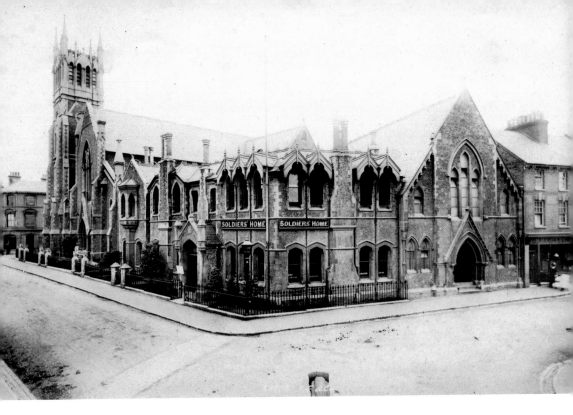

Grosvenor Road Soldiers' Home

Adjoining the Methodist church is the Grosvenor Road Soldiers' Home, shown in an early photograph from around 1905. The soldiers' homes provided comfortable environments in which troops could relax off duty, with reading rooms, games rooms, and refreshments. Today the Soldiers' Home has been converted into private residences.

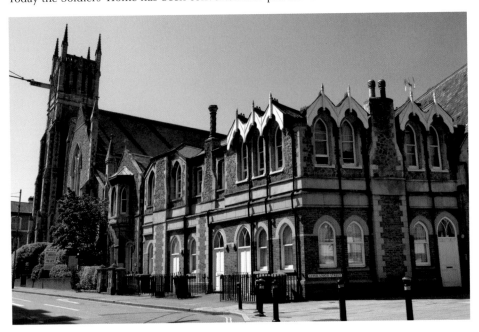

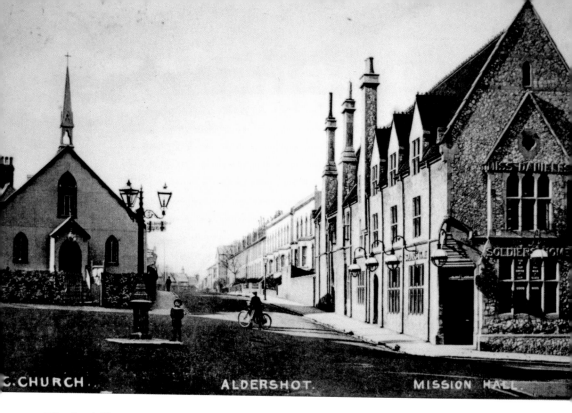

C.CHURCH. ALDERSHOT. MISSION HALL.

Miss Daniell's Home and the Roman Catholic Church

On the corner of Barrack Road and Edward Street stood the first of the soldiers' homes, founded by Mrs Louisa Daniell in 1863 and shown in 1907 on the right in the upper photograph. Adjacent is the temporary Roman Catholic church erected in 1872. This was replaced by the imposing church of St Joseph in 1912, seen on the left in the modern view. To the right, Miss Daniell's home has been replaced by Havelock House.

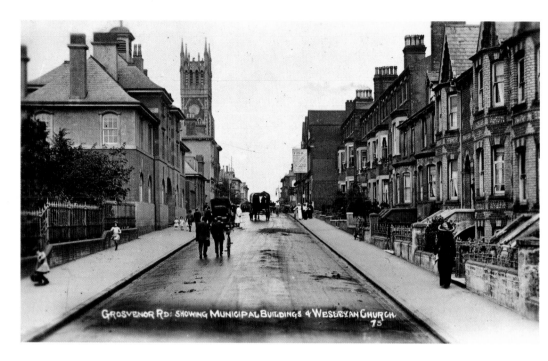

Grosvenor Road

Looking north along Grosvenor Road around 1910, the right-hand side is mainly residential while on the left are the Municipal Gardens, the town hall built in 1904, the fire station, and in the distance is the Methodist church. The Gardens, old town hall and church remain in the modern view, although on the right the Victorian houses have been replaced by modern homes.

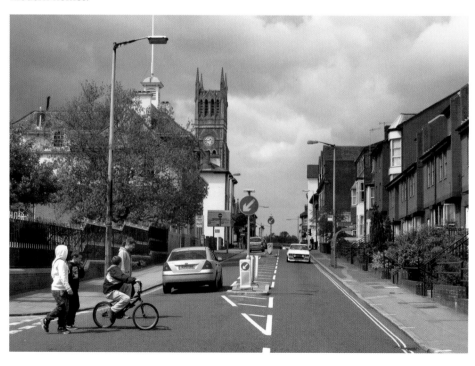

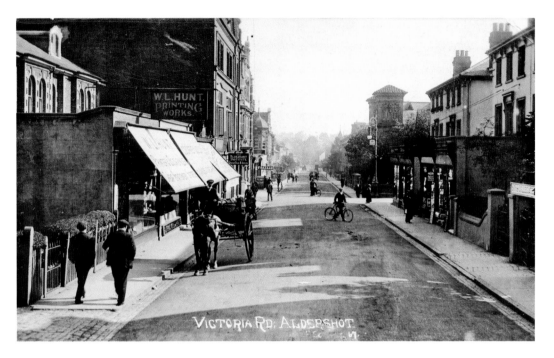

Victoria Road

Originally Victoria Road was a residential street but as the town grew nearly all the buildings were converted into shops, as shown in the photograph from around 1910. Above the modern shopfronts the buildings are still recognisable in the present-day photograph. On the right-hand side in both pictures can be seen the towers of the Presbyterian church which was begun in 1863 and completed in 1869.

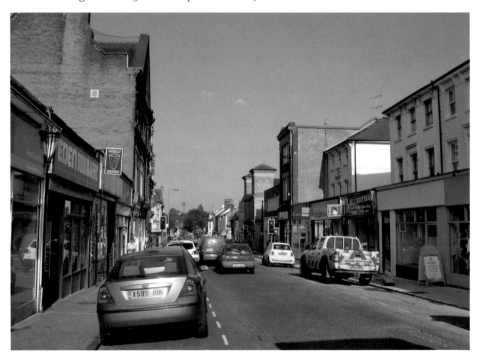

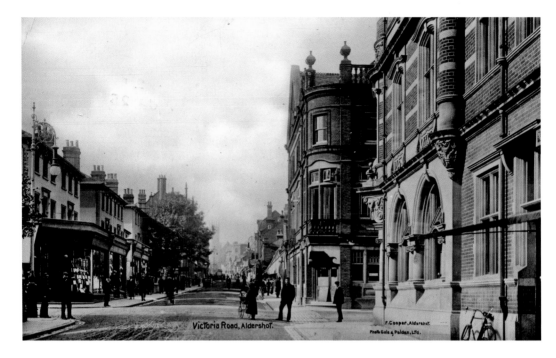

Victoria Road from the Post Office

Looking west up Victoria Road in 1909, the tower of the Methodist church can be seen in the distance, while on the right is the post office built in 1902 and the Aldershot Institute, erected in 1887 by public subscription. Behind the trees on the left was the Church of England Soldiers' Institute. The view is still recognisable in the modern view, but the Soldiers' Institute has been replaced by a modern shop building.

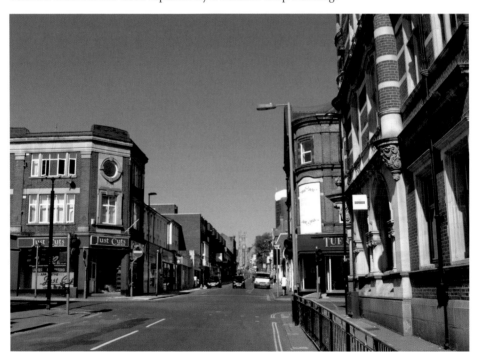

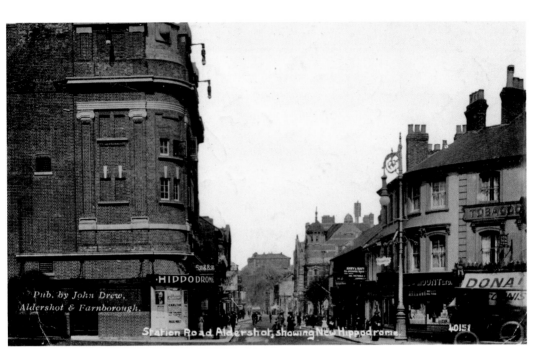

Station Road

Photographed around 1914, the view down Station Road from the junction with The Grove shows the Hippodrome Theatre on the left, midway down on the right is the post office, and on the hill in the distance can be seen Gun Hill House, the QARANC Officers' Mess. Of these, only the post office can still be seen in the modern view, the Hippodrome has been replaced by an office block and Gun Hill House is obscured by trees.

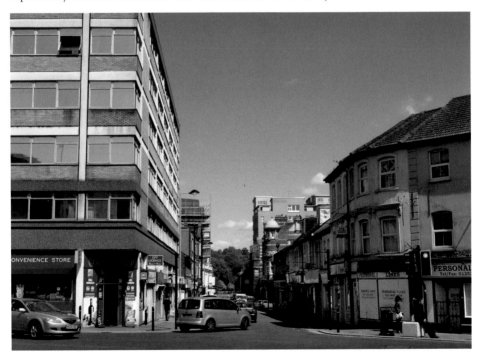

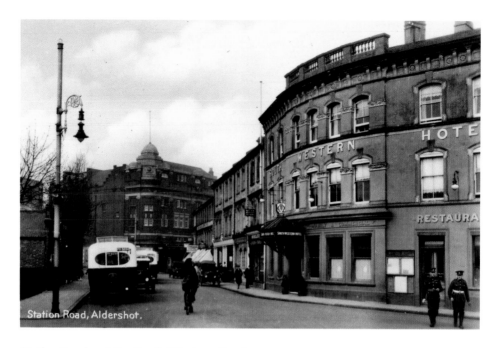

Station Road, Aldershot.

Station Road and the South Western Hotel

In the view down Station Road from the 1930s, the Hippodrome variety theatre can be seen at the junction with Birchett Road, while in the foreground is the large South Western Hotel, built in 1867. In the modern photograph the theatre has been replaced by the Hippodrome House office block from the 1960s, while the South Western has been reduced to about a third of its original size and is now the Funky End bar.

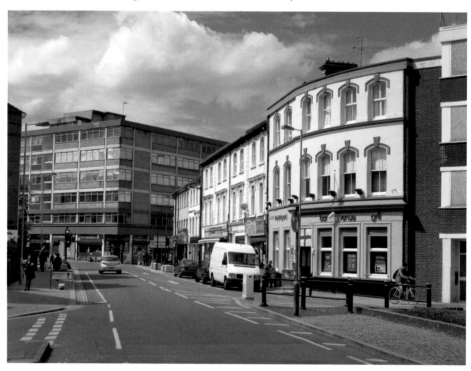

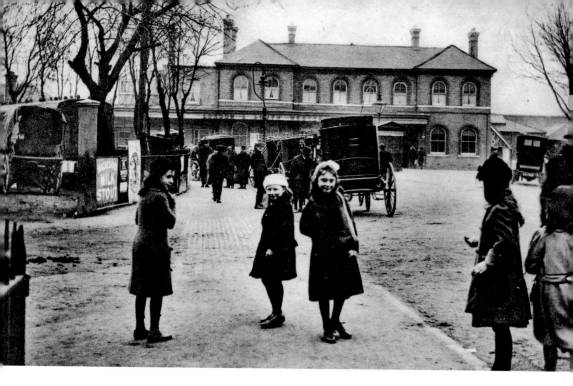

The Railway Station Approach

When the Camp was first established the nearest railway station was Tongham, but with the rapid growth of the town a line was brought to Aldershot and the station was opened in 1870. The photograph from around 1910 shows lines of horse-drawn cabs waiting for passengers and on the left is a carriage in the sidings. The station building remains in use today, but the sidings are now a car park and the taxis are motor-powered.

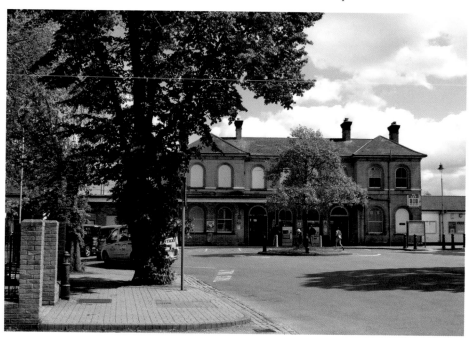

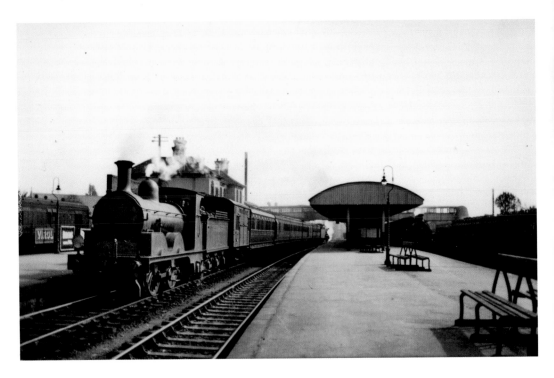

Aldershot Station

Trains to Aldershot were operated by the London and South Western Railway and were a vital communications link. As well as civilian traffic, railways were essential for troop movements. The upper photograph shows the scene when trains were steam-hauled before the line was electrified in 1939. In the 2012 view the station buildings are little changed, but the trains are far removed from those of the steam era.

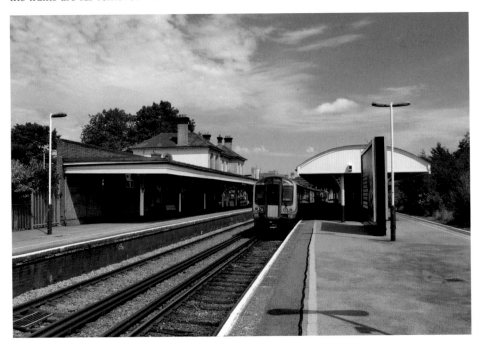

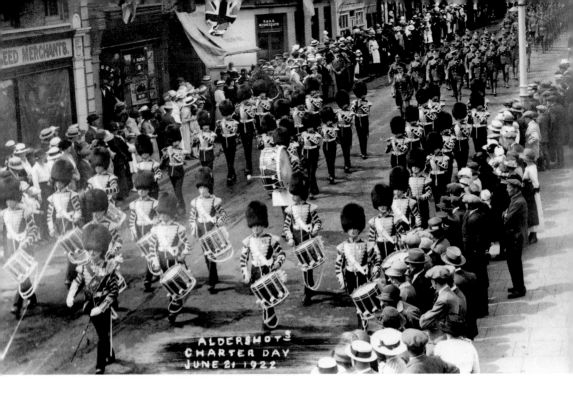

ALDERSHOTS
CHARTER DAY
JUNE 21 1922

Charter Day Parade in High Street

There were great celebrations on 21 June 1922 to mark the receipt of the charter making Aldershot a municipal borough. A grand procession marched from Salamanca Barracks to Manor Park, where the charter was presented. Led by the band of the Grenadier Guards, the parade is pictured here marching along the High Street past Frickers Hotel, opposite the junction with Redan Road. The hotel closed in 1960 and the building is now used as offices.

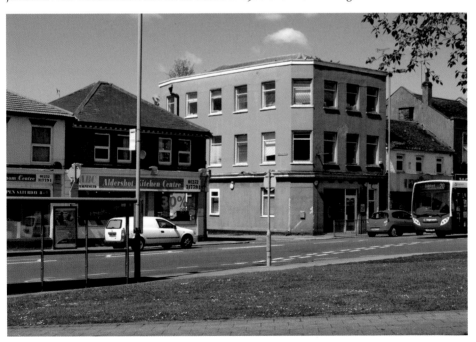

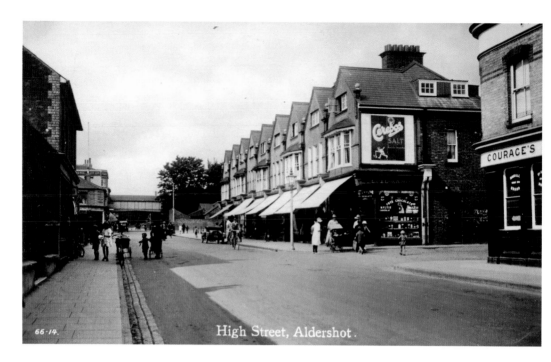

High Street, Aldershot.

High Street from the Beehive

This view of the lower High Street from the 1920s looks past the line of shops to the railway bridge at the bottom of Redan Hill. On the right is the corner of the Beehive pub, one of the original pubs of Aldershot village although it was rebuilt at some time between 1855 and 1871. The modern view is little changed; even the shape of the shadow on the left is the same in both photographs.

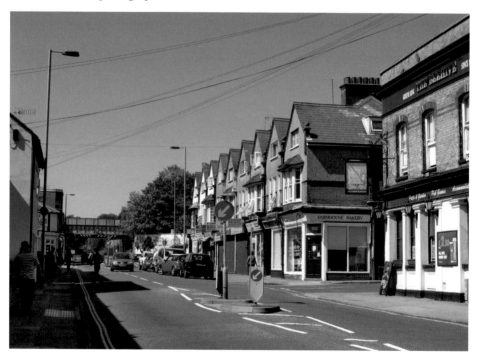

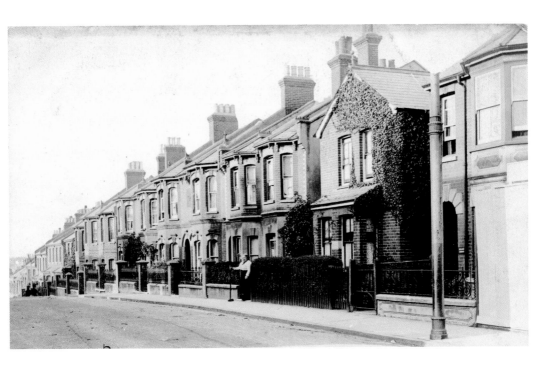

Perowne Street

As Aldershot town grew in prosperity towards the end of the nineteenth century, a number of new residential streets were built to accommodate the increasing population. The photograph of Perowne Street from around 1920 shows a typical example of one such street of Victorian houses. Today many of these houses are largely unchanged externally, other than modernisations such as new windows, and these streets give Aldershot much of its character.

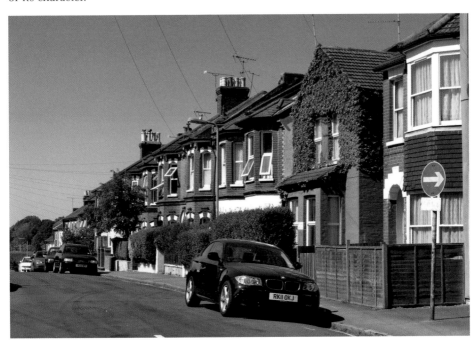

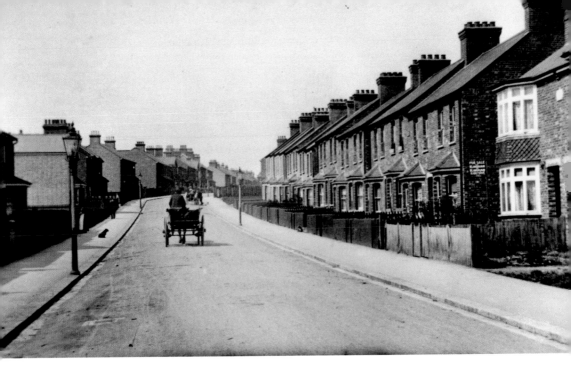

Holly Road

The road takes its name from Holly Farm, which existed before the establishment of the Army Camp. The houses were built between 1890 and 1910 on the old farm land. This is another street which has retained its character and the main differences between the older photograph from the 1930s and the present-day view are the number of cars, telegraph poles, and the replacement of gas lamps with electric street-lights.

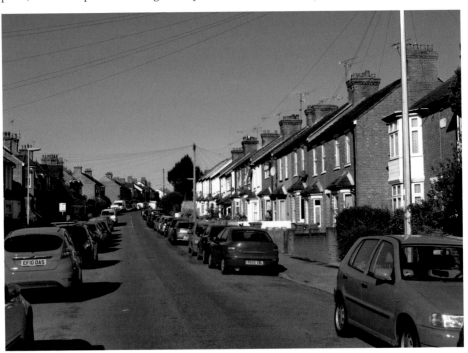

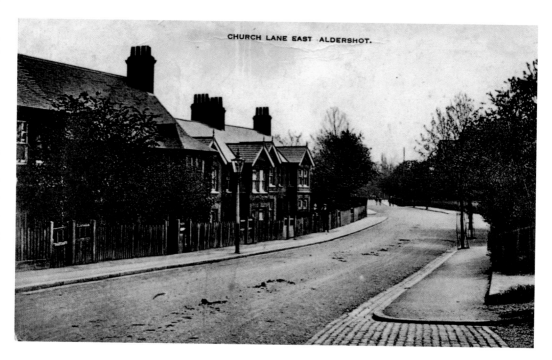

CHURCH LANE EAST ALDERSHOT.

Church Lane East

Although this was one of the roads of the original Aldershot village, leading to the parish church, it was not developed for housing until around 1900. The upper photograph was taken before the First World War and shows some of the smart houses built along Church Lane, indicating the growing prosperity of the town. Once again the older buildings are clearly identifiable in the modern photograph.

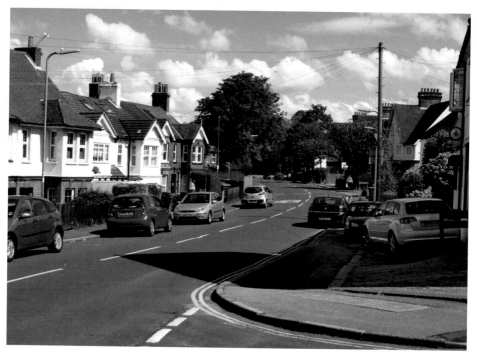

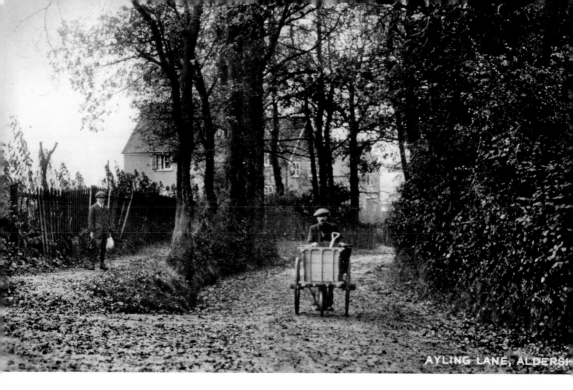

AYLING LANE, ALDERSH

Ayling Lane

The upper photograph dates from around 1937 and shows how the area outside the town centre retained its rural character until well into the twentieth century. It was not until the 1920s that houses began to be built along Ayling Lane and even then development was slow, with a farm at the lower end operating until after the Second World War. Traces of the old lane and banks can still be identified today.

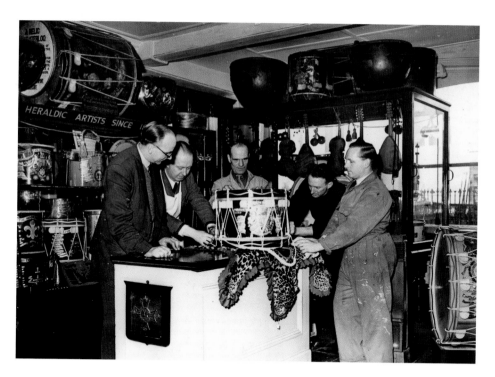

George Potter and Company

One of the most famous businesses in Aldershot was George Potter and Company, who produced drums and other musical instruments for the Army. The older photograph dates from around 1950 and shows workers in their showroom at the corner of Grosvenor Road and Queen's Road, admiring the fine work of Potter's heraldic artists on a military drum. The firm closed at the beginning of this century and its shop, built in 1859, currently stands empty.

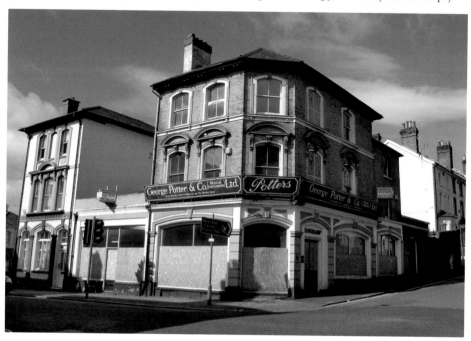

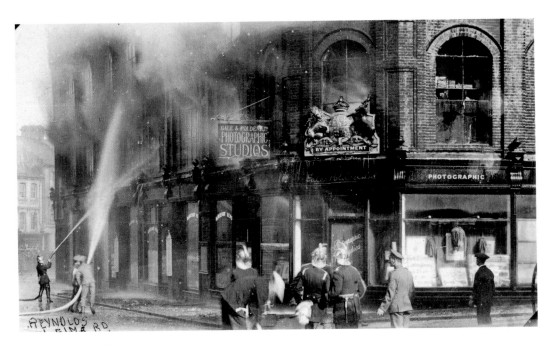

Gale and Polden

Gale and Polden established their printing works in Aldershot in 1893 and it grew to be one of the town's largest businesses. There was a disastrous fire in 1918, and in the upper photograph men of the Aldershot volunteer fire brigade tackle the blaze. The firm was taken over by Robert Maxwell and closed in 1981. The site is now occupied by flats, but the design echoes the shape of the old printing works.

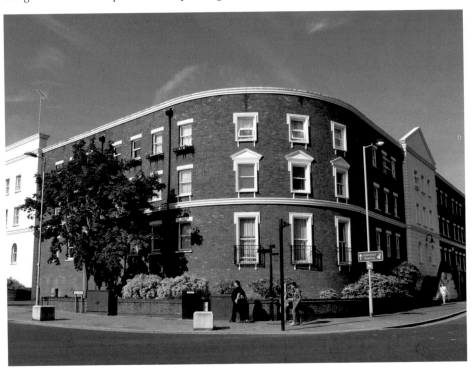

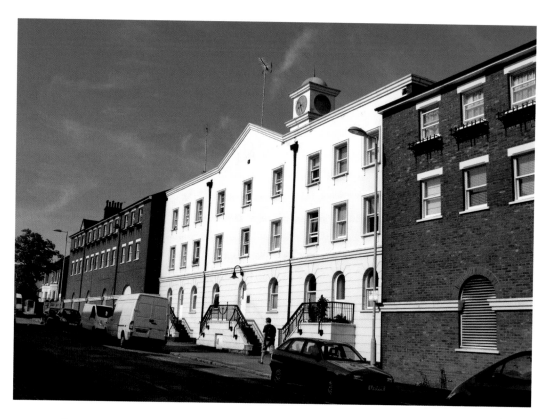

Wellington Works

Along The Grove the new flats on the site of Gale and Polden's large Wellington works continue the theme of reflecting the architecture of the building they replaced. The bottom photograph shows the inner courtyard of the works in 1919, just after they were rebuilt after the 1918 fire. This gives an idea of how many workers were employed in this busy factory, which was one of the town's largest employers.

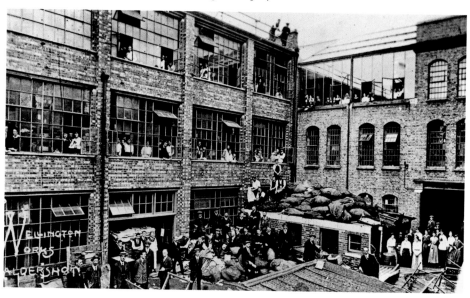

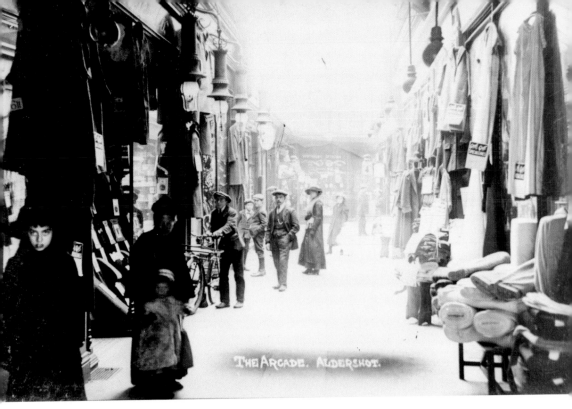

THE ARCADE. ALDERSHOT.

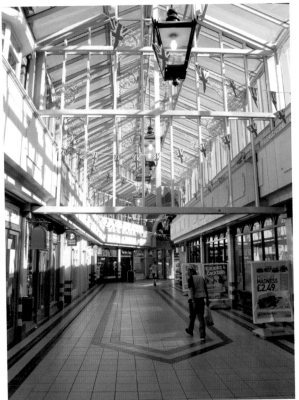

The Arcade

The original arcade, shown in the photograph from the early twentieth century, was built in 1896 and ran from Wellington Street to Victoria Road. It continued to operate until the 1980s with a number of small specialist independent shops. Despite large public protests, developers were permitted to demolish the Victorian arcade and it was replaced with a modern imitation, which has none of the character of the original and has seldom been fully occupied.

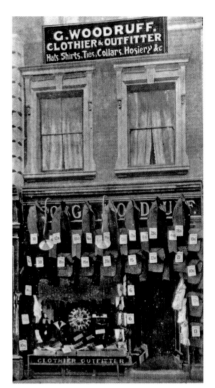

Edgar Jerome's Outfitters

This well-known shop in Wellington Street was built in 1860, and at the time of the early photograph (around 1920) it was George Woodruff's outfitters. The shop was bought by Edgar Jerome in 1923 and continues to trade to this day. It is still run by Edgar's descendants making it one of the oldest family firms in the town, and in the modern photograph is Mr John Jerome in his shop which retains its traditional character.

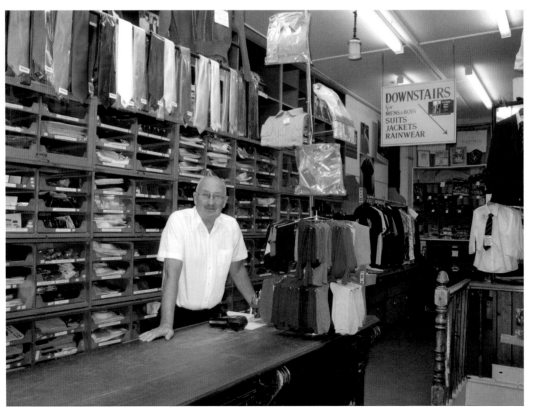

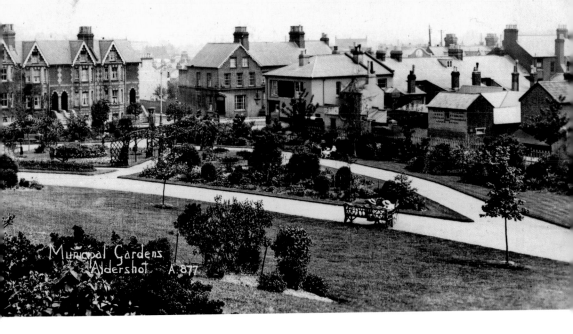

Municipal Gardens

Between 1894 and 1898 the Town Council purchased tracts of land from the Church authorities for municipal use. The ancient 'Parish Clerk's Land' was laid out as the Municipal Gardens, which were opened for public use in 1904 and thirty-two trees were planted on 'Arbour Day', 13 December 1905. The older photograph shows the Gardens around 1915 when the trees were still young. In the modern photograph these have grown to maturity and are joined by some later planting.

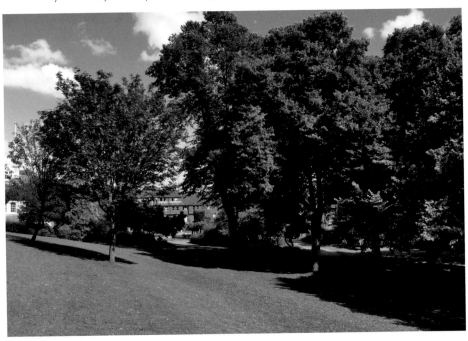

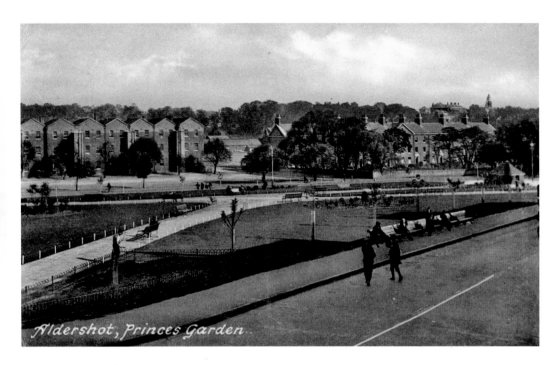

Aldershot, Princes Garden

Princes Gardens

The area which is now the Princes Gardens was where the Royal Engineers set up their base in late 1853 to survey the land for the Camp. It remained the Royal Engineers Yard until bought by the Council in 1930 and laid out as gardens. The top photograph is from 1936 and looks across to the old Talavera Infantry Barracks. Prominent in the modern picture is the new bandstand, opened on 2 June 2012 to mark the Queen's Diamond Jubilee.

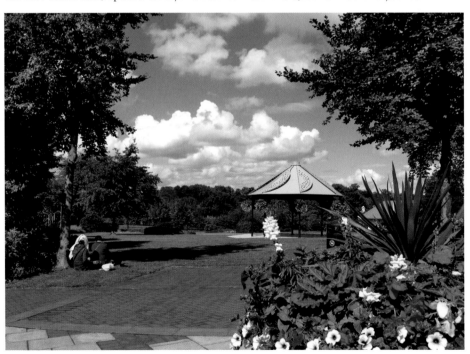

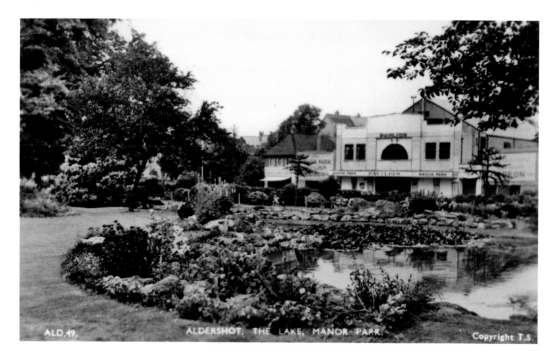

ALD.49. ALDERSHOT, THE LAKE, MANOR PARK. Copyright T.S.

Manor Park

The grounds of the old Aldershot Manor were purchased by the Council in 1919 and given to the people as a public park. The older photograph dates from around 1955 and shows the lake by the High Street, and across the other side of the road is the Pavilion Cinema, built in 1926. The peaceful scene around the lake remains, but the Pavilion was demolished in 1956 and an office block now stands in its place.

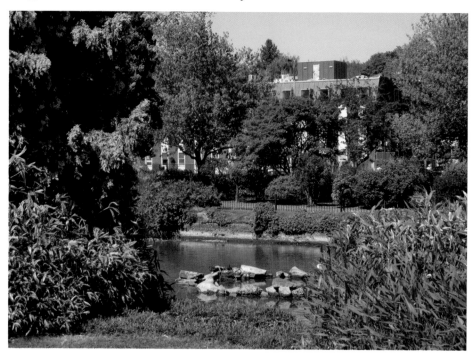

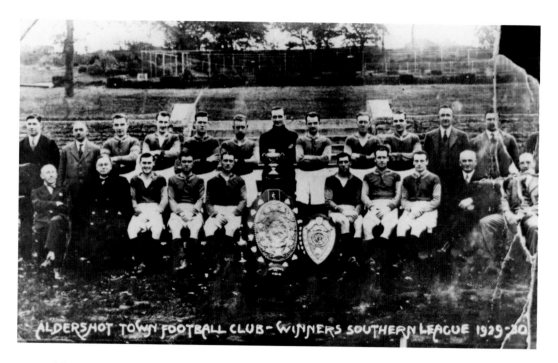

ALDERSHOT TOWN FOOTBALL CLUB – WINNERS SOUTHERN LEAGUE 1929-30

Aldershot Town Football Club

The football club was formed in December 1926 and leased the Recreation Ground from the Council. They joined the Southern League and played their first match on 27 August 1927. The old photograph, unfortunately damaged on the right side, shows the team which won the Southern League in the 1929/30 season. The team continues to enjoy enthusiastic support and a highlight of the 2011/12 season was hosting Manchester United for a match in the Carling Cup.

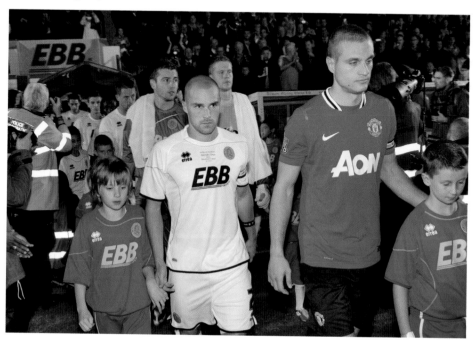

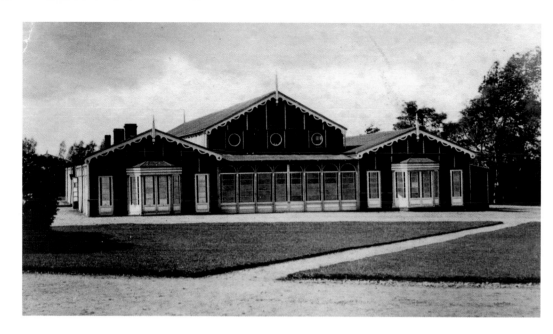

The Officers' Club

The Aldershot Officers' Club was established in 1859 as somewhere for the army officers to take their meals and spend time off duty, before the establishment of proper officers' messes. It was very popular and expanded to include a ballroom, games rooms, a reading room, and many sporting facilities. In the late twentieth century declining membership resulted in its redevelopment as Potters International Hotel, which at the back retains part of the old building for the Officers' Club.

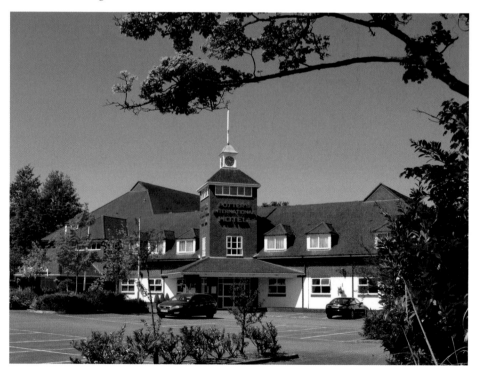

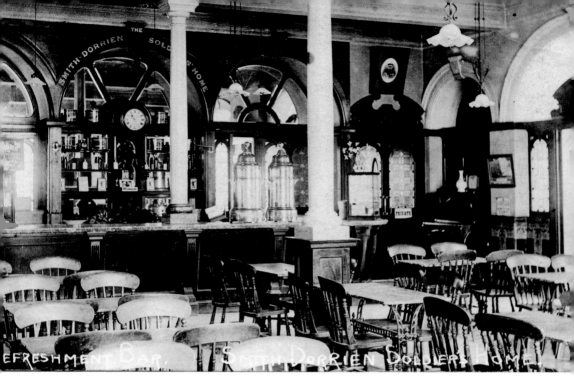

The Smith-Dorrien Soldiers' Home

For off-duty soldiers in the garrison during the later nineteenth and early twentieth centuries, the soldiers' homes provided a comfortable escape from their spartan barracks. Smith-Dorrien House at the southern end of Queen's Avenue was the Methodist soldiers' home founded in 1908 and the photograph shows the (strictly non-alcoholic) refreshment bar. In later years Smith-Dorrien was used as offices, but many of the original features can still be seen.

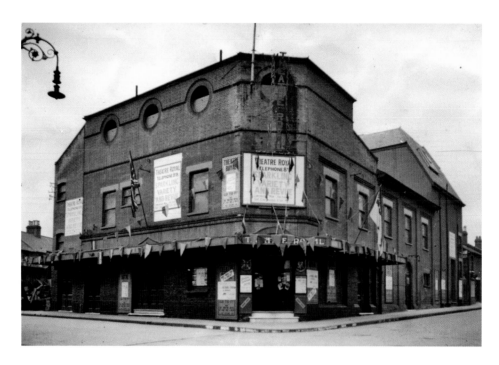

The Theatre Royal

Situated on the corner of Gordon Road and Birchett Road, the Theatre Royal was opened in 1891. The theatre went bankrupt in the 1930s and re-opened as a variety theatre in 1940, which is how it is shown in the upper photograph from 1945. It was leased by the Playgoers' Society in 1947 but closed in 1953 and was demolished in 1959. A garage occupied the site until replaced by the Matinee House flats, completed in 2011.

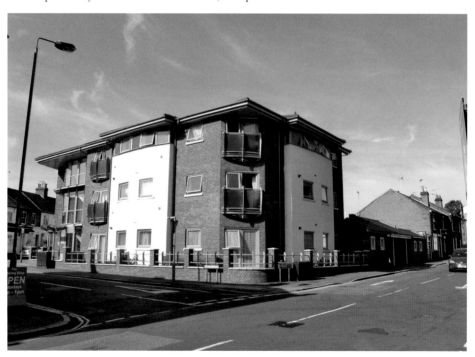

The Hippodrome

Aldershot's fine variety theatre, the Hippodrome, opened on 3 February 1913 on the corner of Station Road and Birchett Road. It was one of southern England's largest venues, able to seat up to 1,700, and was hugely popular during its fifty-year life. The theatre was demolished in 1962 and replaced by the dull and unimaginative Hippodrome House office block.

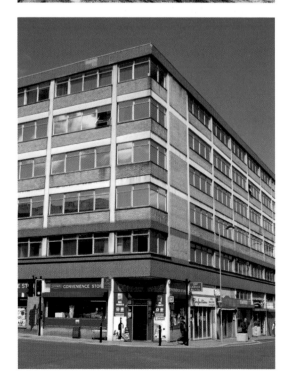

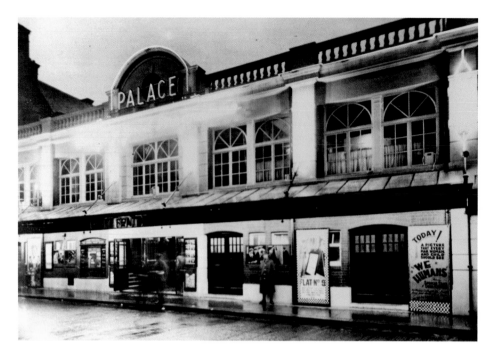

The Palace Cinema

The Palace was the first purpose-built cinema in Aldershot and opened on Boxing Day 1912. The older photograph shows it ablaze with lights in its heyday around 1933. It closed as a cinema in 1985 and was turned into the Cheeks nightclub. In 2010 it became a live music venue and reverted to the original name of the Palace. Unfortunately the venture failed and it closed in January 2011. This Grade II listed building now stands empty.

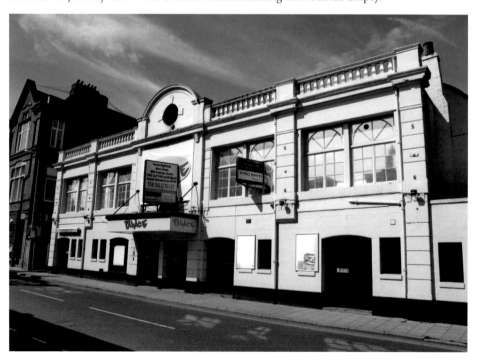

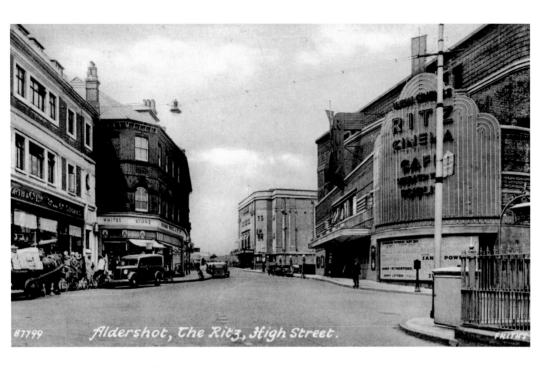

Aldershot, The Ritz, High Street.

The Ritz and Empire Cinemas

When the Council took over the land that was previously the Royal Engineers' Yard, part of it was used for two new cinemas. The first was the Empire, opened on 1 August 1930, followed by the Ritz, which opened on 15 May 1937. Both are shown in the photograph from 1947, the Ritz in the right foreground and the Empire behind. Today the Empire is the King's church and the Ritz has become the Gala Bingo hall.

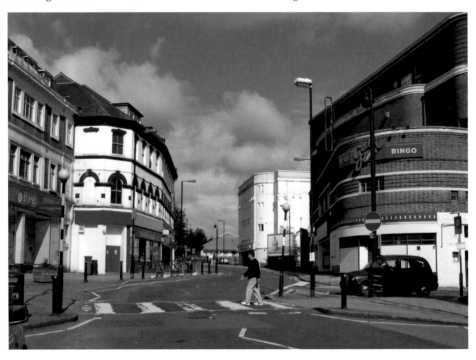

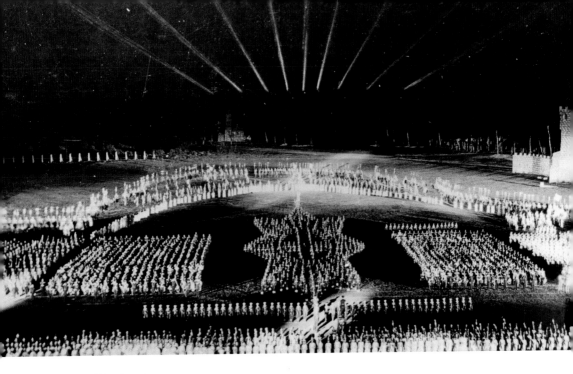

The Aldershot Tattoo

Between the two World Wars the Aldershot Tattoos were huge spectaculars, with up to 5,000 soldiers in the specially constructed Rushmoor Arena. The upper photograph shows the searchlight finale of the 1929 Tattoo, which had a total attendance of 306,500 over its four days. The modern-day Aldershot Army shows are smaller and held on Queen's Parade but remain extremely popular. Here the Red Devils, the Parachute Regiment's free-fall parachute display team, land in the arena during the 2012 show.

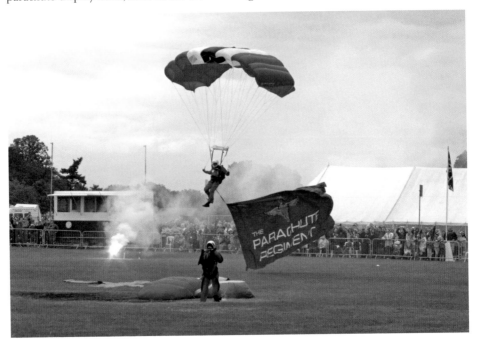

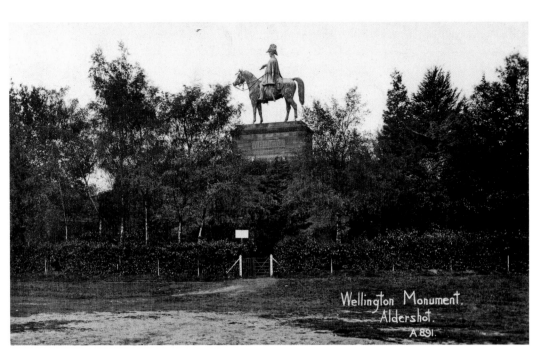

Wellington Monument.
Aldershot.
A 891.

The Wellington Statue

Still the largest equestrian statue in the country at 28 feet high, the great Wellington Statue by Matthew Cotes Wyatt originally stood on the Hyde Park Corner arch in London. It was re-erected in Aldershot in 1885 on Round Hill, adjacent to the Royal garrison church, and became a symbol of Aldershot's military heritage. The older photograph is from around 1920, while the modern photograph shows the results of the restoration that took place at the start of this century.

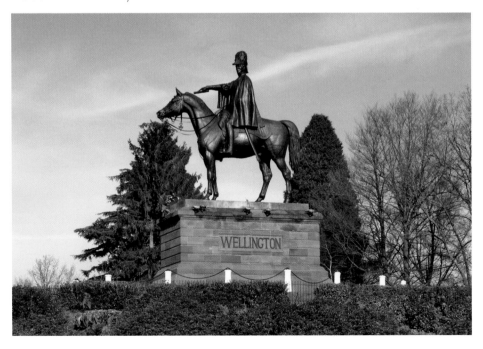

WELLINGTON

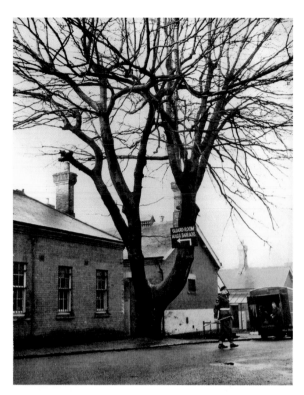

The Gordon Oak

This magnificent oak was brought to Aldershot by General Charles Gordon, later famous at Khartoum, after a trip to Jerusalem in 1883. It was planted in Aldershot to symbolise 'Endurance, strength and triumph in the Home of the British Army'. The upper photograph shows the oak around 1960 with the guardroom of Maida Barracks, now demolished. The oak still stands on Hospital Road, the path to the right marking the site of the old barracks entrance.

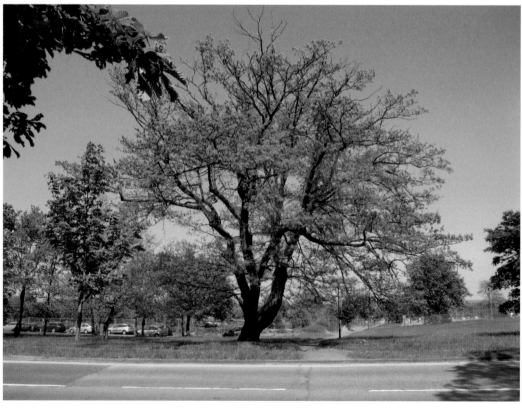

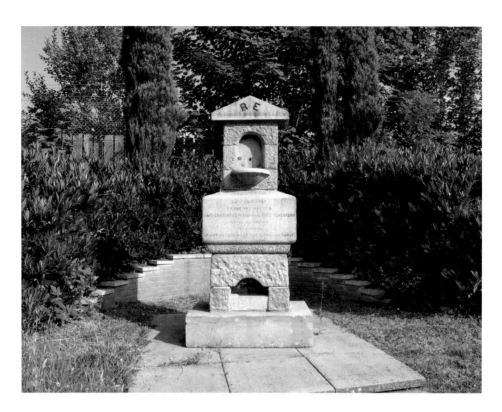

Beresford Memorial

This horses' drinking fountain was erected on the Farnborough Road in 1910 to mark the place where Captain Charles Beresford of the Royal Engineers lost his life in a brave attempt to stop a runaway horse which was endangering passers-by. In recognition of his selfless act Beresford was honoured by a huge military funeral, seen in the lower photograph making its way up Queen's Avenue on route to the Military Cemetery.

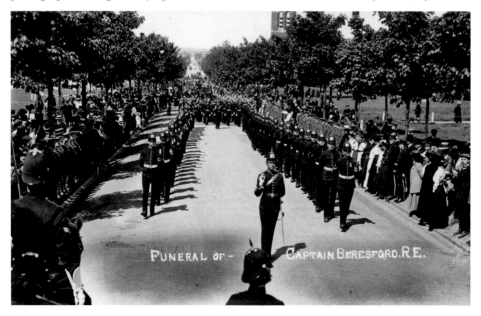

FUNERAL OF - CAPTAIN BERESFORD. R.E.

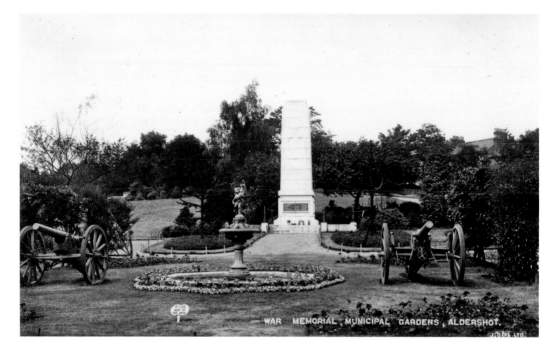

WAR MEMORIAL, MUNICIPAL GARDENS, ALDERSHOT.

Municipal War Memorial

The memorial to the people of Aldershot who lost their lives in the First World War was unveiled in the Municipal Gardens on 18 March 1925 by the Duke of Gloucester. In the older photograph, from around 1927, the memorial is flanked by two captured field guns, one German and one Turkish, which were removed in the Second World War. In the modern view is the new fountain, which was part of a restoration of the Gardens in 2000.

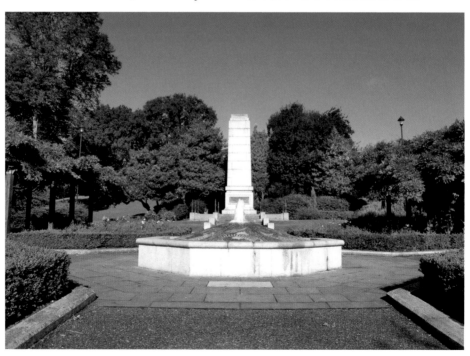

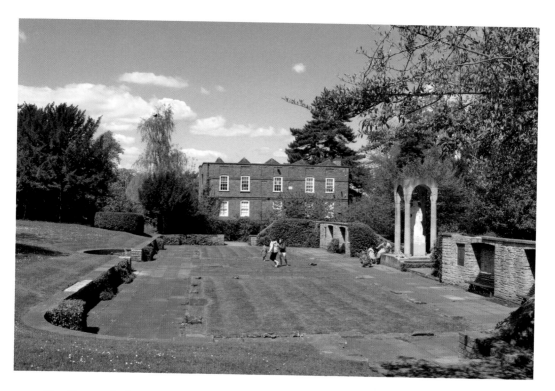

The Heroes Shrine

This national memorial to those killed during the Battle of Britain and by other enemy bombing in the Second World War was unveiled by the Duchess of Gloucester on 5 May 1950. It contains stones from thirty-four cities which suffered the most severe bombing, and the central sculpture is *Christ Stilling the Storm* by Josephina de Vasconcellos. In the 1990s the stones were re-positioned to the present layout, but the original rockeries are shown in the lower photograph from around 1955.

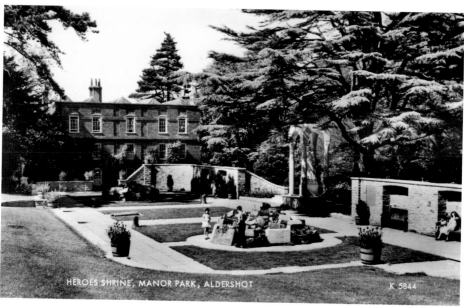

HEROES SHRINE, MANOR PARK, ALDERSHOT K 5844

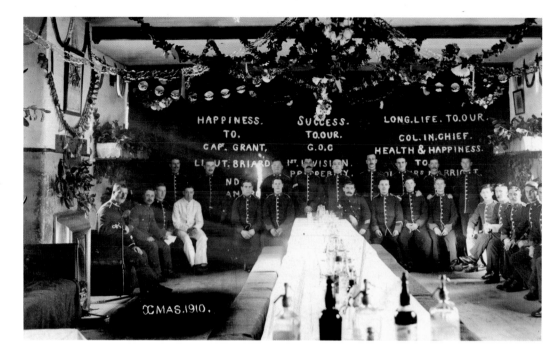

HAPPINESS.
TO.
CAP. GRANT,
LIEUT. BRIARD
ND
AM

SUCCESS.
TO.OUR.
G.O.C
1ST. DIVISION.
PROPERTY.

LONG.LIFE. TO.OUR.
COL. IN. CHIEF.
HEALTH & HAPPINESS.
TO

XMAS.1910.

Christmas in Camp
Men of the 1st Battalion, the Norfolk Regiment await their Christmas dinner in 1910. They have highly decorated their barrack room, one of the single-storey blocks in Malplaquet Barracks, and the table is ready for the festive feast.

Acknowledgements

The photographs used in this book are courtesy of the following collections: Aldershot Military Museum; the Prince Consort's Library; Project Allenby Connaught; Edgar Jerome Ltd; and Aldershot Town FC. Other photographs are from the author's collection.

For their assistance with locating photographs and making them available, or for facilitating access to different locations to take the modern views, I am grateful to Major Corin Pearce and Mr Simon Welsh of Headquarters Aldershot Garrison; Justine Tracey of the Aldershot Military Museum; Gill Arnott of Hampshire County Council Arts and Museums Service; Tim Ward and staff at the Prince Consort's Library; John Jerome of Edgar Jerome Ltd; Ian Morsman of Aldershot Town FC; Revd James Martin of the parish church of St Michael the Archangel; Paul Munro of Project Allenby Connaught; and Sarah Rolfe of Aspire Defence Services Ltd.

Many people have been generous in offering assistance, advice and support in the compilation of this book, and I am grateful to Martin Rickard; Alan Grover; Peter and Barbara Reese; Peter Smith; Jeanette Cohen; the committee and members of the Friends of the Aldershot Military Museum; and the many Aldershot people, both military and civilian, that I have met while compiling this book.